This book belongs to

Shireen Salyer
1991

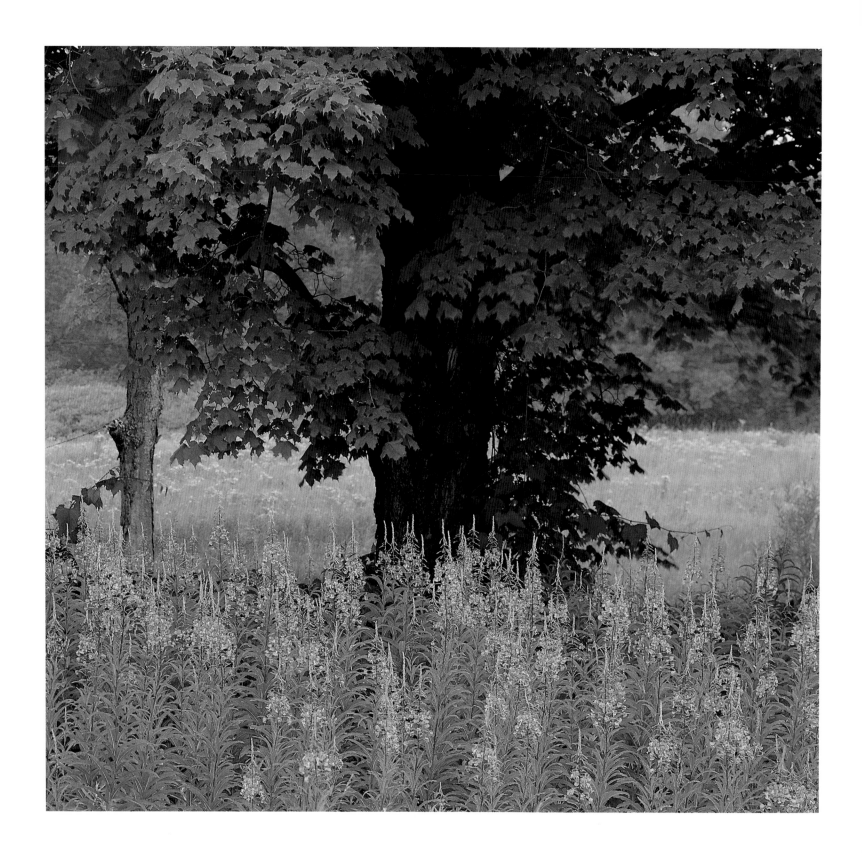

Eastern Wildflowers

A Photographic Celebration
from New England to the Heartland

Written by Rose Houk
Designed and Produced by McQuiston & Partners

Chronicle Books • San Francisco

To Patricia McQuiston

A ranger on horseback in Pine Mountain State Park in Pineville, Kentucky, showed me a purple trillium one day. He didn't know (and neither did I at the time) that the sight of that flower would alter my life. I had spent twenty-one years in ignorance of such beauty, and it seemed that some sort of blindfold had been removed.

This book is as direct an outcome of that first sight as I can trace. Since then, many other people, some whose names have now left me, have added to that experience by sharing their sheer love of flowers.

For this book in particular, botanical consultant Claudia Rector is at the top of the list, for her knowledge, and more for her constant friendship. She must share this spot with Don McQuiston, for his faith and kindness, and of course for his design talents, so obviously displayed here. Frankie Wright, who edited the manuscript, added whatever measure of grace might be found in the words. I thank the people at Chronicle Books for their support as well, and all the fine photographers whose vision has made this book a work of art.

The librarians at the Mesa County Library in Grand Junction, Colorado, also deserve recognition for patiently putting up with an untold number of book requests.

Finally, I thank my mother for that wonderful walk in the Smokies, and always, thank you Michael.

—ROSE HOUK

Copyright © 1989 by McQuiston & Partners, Inc. All rights reserved. No part of this book may be reproduced in any form without written permission from the publisher.

Produced and designed by McQuiston & Partners, Del Mar, California; Edited by Frankie Wright and Robin Witkin; Botanical consultation and review by Claudia Dean Rector; Mechanical production by Joyce Sweet and Kristi Paulson; Composition by TypeLink; Printed in Singapore by Toppan Printing Co., PTE., Ltd., through Palace Press, San Francisco.

Library of Congress Cataloging-in-Publication Data

Houk, Rose, 1950-
 Eastern wildflowers.
 Bibliography: p.106
 Includes index.
 1. Wild flowers—United States. 2. Wild flowers—United States—Pictorial works. I. Title.
QK115.H68 1988 582.13'0973 88-30436
ISBN 0-87701-514-7
ISBN 0-87701-594-5 (Cloth)
10 9 8 7 6 5 4 3 2 1

Distributed in Canada by Raincoast Books
112 East Third Avenue
Vancouver, British Columbia V5T 1C8

Chronicle Books, 275 Fifth Street
San Francisco, California 94103

Contents

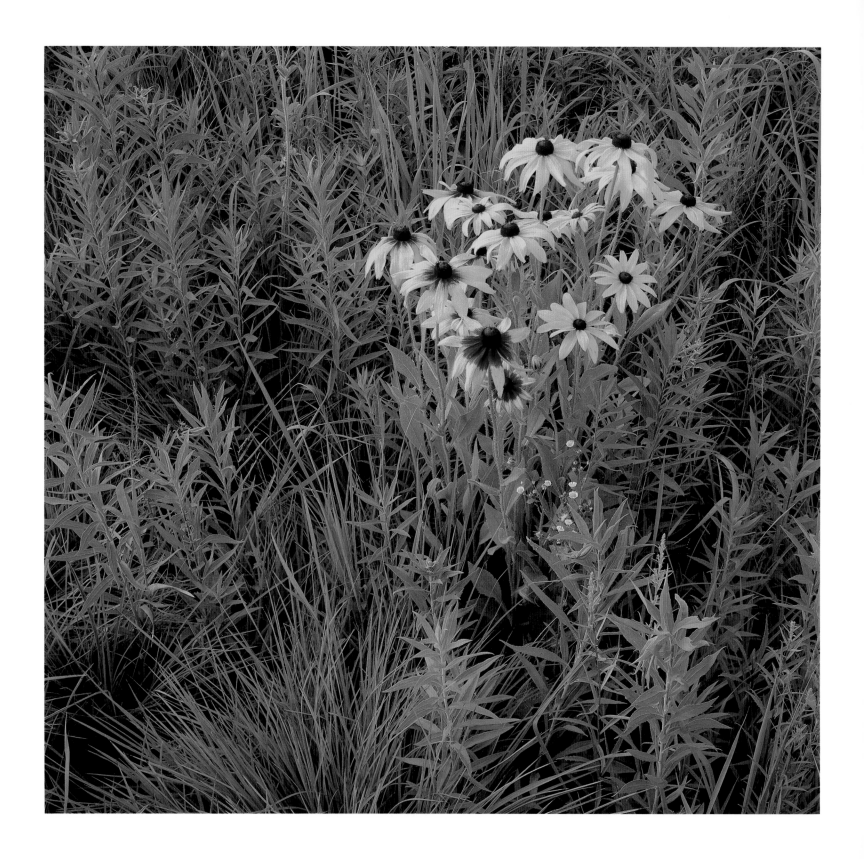

A botanist poses an intriguing question: "What would life be worth without flowers?" The botanist is a professor from Germany, who tells that in the Alps a few small flowers, the edelweiss, are so highly valued that people actively guard them from being picked. In the eastern United States certain wildflowers are likewise jealously protected, such as Furbish's lousewort along the banks of the St. John River in Maine, and the elusive Oconee bells of the Carolina mountains, to note only two of many.

Why *do* we care so much about flowers? What is it about a wildflower that can inspire our reverence, that brings us to our knees to see it more closely, on its terms rather than ours? The professor's answer is simple: We love them because they are beautiful. But more than that, he thinks, flowers are "friendly signposts" in a world that would otherwise be overwhelmed by material concerns.

Their beauty is enough, for many of us, to explain our strong affection. Their array of colors, delicious fragrances, and myriad shapes stir our senses. Wildflowers often present a surprise, a reward for a stroll through the woods or a walk across a field. They can absorb us in many pleasant hours spent photographing or painting them, observing an insect at their doorstep, or studying the infinite details of their structure.

Perhaps they represent freedom, wildlings that we played no part in creating. Neither sown nor cultivated by our hand, they are unexpected and thus treasured all the more. Their presence denotes healthy land, and as we get to know them, they quickly become part of our neighborhood. A

Black-eyed Susan (opposite page) by Willard Clay, butter and eggs (far right) by Teddy Hoskins

friendly flower, nodding as if in recognition, can make us feel at home as much as a familiar house or a memorable smell. So greatly do we admire flowers that we are inclined to obey the Chinese proverb, "If you have two pennies left in the world, buy a loaf of bread with one and a lily with the other."

A word exists that seems tailor-made for wildflower fanciers: "botanophil." Scottish priest Andrew Young borrowed the term from Carolus Linnaeus, to whom we owe the present scientific system for naming and classifying plants. A botanophil, writes Young, is not a scientist as is the botanist. The botanophil spends little time poring over a microscope; instead, he so much enjoys looking for plants that in winter when they are scarce, he hibernates, like the bears.

Hard as they may try, botanophils do not naturally speak Latin or Greek. Botanists may grumble about those who resist learning the language of their science, but to most novices, and even intermediate botanophils, the terminology looms arcane and unapproachable. They find it far easier to remember the common names of flowers, which to them better describe and personalize the object of their affection than do the foreign tongue twisters.

In the eastern United States, common names comprise a fascinating catalogue. Many bring to mind animals—snakeroot, cranesbill, pussytoes, adder's tongue, toadflax, goosefoot, monkeyflower, and turtlehead. We can recall boneset, sneezewort, heal-all, liverwort, feverfew, and colicroot, for the medicinal values they are said to possess. Even simpler are those named for their colors (pinks, lilacs, violets, bluets), for their smell (carrion flower), and even for their sounds (rattlebox). Others, like wake robin and mayapple, tell us of the time of year in which they bloom.

But botanists need a universal language with which to communicate to avoid confusion. Vernacular names of plants, colorful though they may be, vary from place to place. Trillium, for example, carries a host of names in addition to wake robin—bathwort, birthroot, Indian balm, squaw flower, stinking Benjamin, and true love, to list just a few. Golden club is the bog torch to Louisiana bayou dwellers, while New Jersey Pine Barrens residents call it neverwet. One person's dogtooth violet is another's trout lily, and the mayflower for sale on the streets of Boston in the spring (which is really trailing

arbutus) is not the same lily as the Canada mayflower.

Once we gain some practice pronouncing scientific names, we can begin to appreciate their finer points. The Latin and Greek names that Linnaeus ordained often convey interesting clues to a flower's characteristics, origin, or mythology. What Linnaeus did, in fact, by his new system was to simplify an existing hodgepodge of names by devising a classification that reflected natural relationships among living things. He first organized plants into family, then into the finer category of genus, and finally into species. The genus and species then became the flower's name.

The genus is something like a surname, and species is much like a first name. We can illustrate with bloodroot, the early spring flower known to botanists as *Sanguinaria canadensis*. The genus name *Sanguinaria* comes from the Latin word for "bleeding," describing the red liquid that oozes from the root and that makes an excellent red dye. The species name, *canadensis*, is applied to many flowers and signifies northern affinities.

As much as we admire them for the values they represent to us, in truth flowers exist for a more central reason. They have one purpose in their kingdom, which is to provide the seed to reproduce their kind. The way they do this necessarily entails for us knowledge of one of the most interesting and basic concerns of the botanical world—study of flower structure.

Basically, the four floral parts are the stamen, pistil, petal, and sepal, though variations are endless in the flower world. The stamen is the male organ and bears the pollen. The pistil, consisting of stigma, style, and ovary, is the female organ. Petals surround the stamens and pistil, and sepals encase the petals. Sepals are usually green, but if colored they may be mistaken for petals.

Flowers by and large are cross-pollinated, a practice that nature seems to prefer over self-pollination. In cross-pollination, flowers of the same species interbreed, but separate plants are involved. The pollen travels from one plant to another. Once the pollen grains end up on a stigma, each grain sends a tube into the ovules, carrying genetic information from the male parent. The ovules, seeds-to-be, are protected in the ovary, and bear the genetic information of the female

parent. It is here that fertilization occurs. Thus two steps are required—pollination followed by fertilization—for the birth of a new generation of plants.

In addition, seeds must be deposited on suitable sites, by wind, water, or other means, and be treated to proper growing conditions. We have only to think of the fluffy seeds of dandelion or milkweed to appreciate how the wind accomplishes this work. Millions of microscopic seeds of one orchid bloom waft on the air, while the small, perfect spheres that are violet seeds are actually propelled from their capsules like flying ball bearings. On the muddy feet of wading birds the seeds of marsh plants are transported to fertile sites. Other seeds, like those of the sticktights, are hooked and spined, achieving mobility by clinging to our pant legs.

Wind not only carries seeds, but also helps cross-pollinate flowers by distributing or transporting pollen. For a significant number of flowering plants, the grasses for example, wind remains the most important pollinator. But as flowers have advanced, animals have also become essential agents in pollination.

Major animal pollinators—bees, birds, butterflies, bats, and beetles—have evolved some amazingly complex relationships with flowers over the last one hundred and forty million years or so. Insects come in search of the sugary nectar usually hidden deep within a flower. From a distance the overall color of the petals attracts them. As the animal homes in on the flower, lines and speckles on some petals—called honey or nectar guides—lead them straight to the sweet juice. Flower scent also acts as a lure, particularly to nighttime pollinators, for whom bright colors would be a wasted effort.

From the flower's point of view, nectar is the reward for a task the pollinator must perform—gathering and transporting pollen. Flowers possess a clever compendium of tricks to assure that this occurs. Mountain laurel, for instance, is constructed so that the anthers are tucked tightly into pockets on the flower. Upon landing, an insect "springs" them free and is dusted with flying pollen. In monkeyflowers, the stigma is like a big shovel. When a bee pokes its proboscis into the tube-shaped flower, the stigma literally scrapes the pollen off the bee. The two lobes of the stigma then close, encasing the pollen in a safe little chamber.

Nature's purposes are sometimes foiled, however, by incorrigible insects that try to steal nectar but bypass pollen. Bees, for example, will bite small holes in the spur of a columbine to reach the sweet treasure, avoiding contact with the pollen-bearing anthers. Fortunately this "illicit" behavior must not be rampant, because these flowers are still reproducing.

The intricacies of wildflower biology can be endlessly engrossing, but more than this keeps us captivated by flowers. Naturalist and author Hal Borland puts it well: "The flower is not only an efficient achievement; it is beautiful, and it is entitled to be as much of an individual as I am."

The East

Botanophils and others have every reason to rejoice at the sheer abundance of flowers in the eastern United States. Conditions such as temperature and moisture are highly conducive to a wide array of wildflower species, especially perennials which return year after year. The shady north woods, rich deciduous forest, open prairie, and even a tinge of the tropics are all included in this region, offering everything from the lush clamshell orchid, to shy woodland hepaticas, to coarse, showy sunflowers.

For this book, the East begins at the coastal plain of the Atlantic Ocean and extends through the piedmont into the Appalachian Mountains. Beyond the Appalachians is the huge Mississippi River Valley, and across the Mississippi begins the sea of grasslands that swells in a long, gentle plateau to the base of the Rocky Mountains. Our East ends at about the ninety-eighth meridian, a line drawn down through the central Dakotas, Nebraska, Kansas and Oklahoma, into the black prairies of east Texas.

New England earns distinction as a separate section, both for a shared glacial heritage and for a shared human history that make it so much a region unto itself. Coastal plain and piedmont extend from New Jersey, south along the mid-Atlantic states, down to the subtropics of southern Florida, and over into Louisiana and Texas. The Appalachians include the Great Smoky Mountains, the Alleghenies, the Blue Ridge, and other ranges which trend northeast to southwest down through the interior of the eastern states. (The Green and the

9

White mountain ranges of New England and the mountains in Maine also properly belong to the Appalachian system, but we have here kept them within New England.) Beyond the mountains rests the Heartland, a huge swath of land from Minnesota south to Texas. This is the nation's great midsection, the Midwest defined generously; the three major plant communities of the East—coniferous forests, deciduous woodlands, and prairie—are all represented within its boundaries.

Though a number of rare and uncommon flowers can be found in the East, the flora also exhibit a decidedly cosmopolitan character. When it comes to wildflowers, someone who grew up in Michigan will find a great deal in common with a southern highlander or a Connecticut Yankee. Trilliums, violets, daisies, asters, and a number of others are found in all the regions.

One reason for this widespread distribution is that the East does not experience the climatic extremes found in the West. The predominance of deciduous forest and evenness of precipitation partly explain this condition. Overall, it is a temperate region. East of the Mississippi, annual rainfall ranges from 80 inches in South Carolina to 28 inches in western Wisconsin. In contrast, the West swings from 144 inches on Washington's Olympic Peninsula to an inch and a half at Death Valley, California. And though the Appalachian Mountains do act as something of a barrier to plant dispersal, they do not create as drastic an obstacle as do the high mountains in the West.

The flowers in this book were chosen first because they are likely to be seen in the woods, along a stream, in a meadow or swamp, or beside roads and trails. Included are only herbaceous species, regrettably no shrubs, vines, or trees. We have tried to include only those that, to the best of our knowledge, are native to the eastern United States. In early times, plants along with people made their way across the Atlantic in boats, flourishing wherever they put down roots. Given the number of introduced plants that have become naturalized, it is sometimes difficult to be absolutely certain a plant is not an immigrant. Often the most abundant flowers, like Queen Anne's lace, hawkweed, and ox-eye daisy, are imports.

We have not intended to provide a field guide for identifying wildflowers. Many guides to specific states and regions already exist, and we urge anyone interested in flowers to carry a field guide as you travel and expand your knowledge of wildflowers. Rather, this book celebrates the beauty and specialness of flowers. The photographs were chosen not so much for their documentary value as for their artistry. We have sought also to pass along some interesting tidbits about a flower's biology, folklore, and medicinal uses. However, when a plant's alleged curative or food properties are mentioned, it is *not* to be considered an endorsement that such a use is either beneficial or safe.

A mention about flower collecting is in order. Most states now have laws to protect certain rare or endangered species of plants. All national parks and monuments prohibit collecting of any kind within their boundaries. Likewise sanctuaries and preserves owned by private groups or individuals deny picking or digging of flowers. The best "rule" to follow is one guided by a personal ethic towards the land. Never dig up a plant by its roots. Most wildflowers have exacting environmental requirements, and transplants usually fail. Removing plants only deprives someone else of the joy of seeing the flower in its own home, where it is best left untouched. When in doubt, always err on the side of conservatism. Many nurseries and companies sell seeds, bulbs, and cuttings, and native plant societies are also good repositories of information for wildflower cultivators.

Burr marigolds (Devil's pitchfork)

by Michael Magnuson

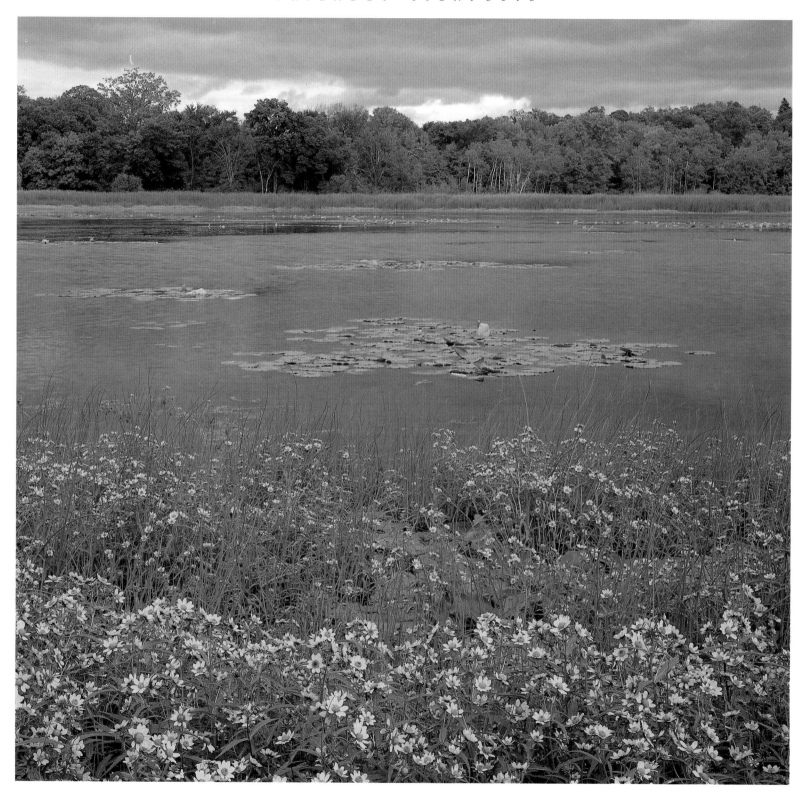

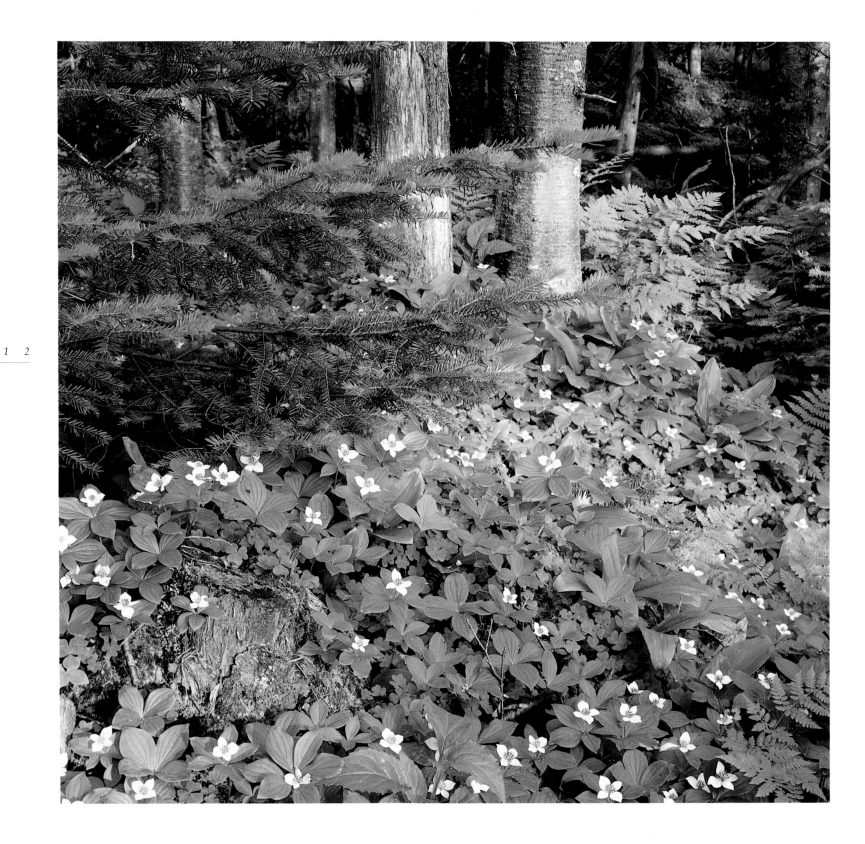

A GOODE COUNTREY

NEW ENGLAND

*I*n the town of Kent, Connecticut, a prize is given to the person who can guess—to the hour and to the minute—when the ice will begin to thaw on the Housatonic River.

In New England the end of winter is a cause for celebration. Each year, when frigidity holds the region in a hammerlock grip, residents are reminded that the Ice Age was not so far in the past. Indeed, New England owes many features of the landscape, and the nature of its plant community, to glaciers.

From the shores of Cape Cod, to the mountains of Vermont, to the forests and lakes of Maine, the legible signature of glaciers has been scrawled on the land. The ponderous frozen masses, rivers of ice a mile or two thick, flowed over the surface of the region, etching it like acid on a copper printing plate. In a historic sense New England can boast great age, but in geologic terms it is in some ways one of the youngest landscapes in the country.

In the farthest north, brooding spruce-fir forests with mossy bogs and acidic soils cover the glacial-pocked land. The trees' evergreenness lets them begin to photosynthesize as early in the spring as possible to counteract the short growing season. Solid ranks of deciduous woods cloak lower hills and valleys, in autumn putting on one of the greatest shows on earth. The deciduous habit is their way of surviving winter cold. In spring these forests are rich with wildflowers, from the bravest hepatica in March, through July's flamboyant lilies, until the display of purple asters culminates in fall. Stunted, wind-bent pines and oaks line the coast adding fur-

Bunchberry (facing page)

by Ed Cooper, trout lily (far right)

by Bruce Hoskins

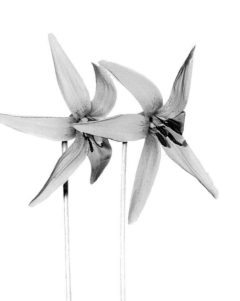

ther diversity to New England's vegetation scene.

This pattern of vegetation began to develop after the last glaciers liberated New England, only about 12,000 years ago. But before they receded, the glaciers ground away at the land, creating large depressions called kettles, now lakes; depositing ridges of debris called moraines; failing against the defiant knolls called monadnocks; and, leaving huge lonely boulders called erratics.

The first settlers learned quickly of the legacy of the glaciers. When they tried to plow the ground, they struck little else but rocks (which were dutifully hauled away in stoneboats and then strung into the miles of stone fences that are a New England trademark). The rocks—and what impoverished soil remained from the glacial scourings—was the land in which the farmers had to grow their food. New Englander Ezra Stiles made a rhyme of it: "Nature out of her boundless store/threw rocks together and did no more."

Her stone walls, classic white-steepled churches on village greens, and red barns nestled in quiet valleys are all part of the pastoral picture New England promotes to tourists. Though these features make nice snapshots (and are no less real), there's more to New England than meets the casual eye.

It's a good thing that the people who settled New England were hardy souls. They had to be. The Yankee virtues of thrift, independence, and discipline were absolute necessities for surviving the "stern and stony terrain" that greeted the passengers of the *Mayflower* in their new homeland. Their descendants would remember especially the winter of 1816, popularly known as "Eighteen Hundred and Froze to Death." Maine residents say they have but two seasons—winter and July. Congregationalist minister Timothy Dwight, in one of his eighteenth-century letters, wrote that "The great distinction between the climate of New England and that of European countries lying in the same latitudes . . . is the peculiar coldness of its winters."

There *is* a springtime, called the unlocking, when the first shoots of skunk cabbage poke through and sap starts to rise in the sugar maples. But it is equally notorious. Mark Twain, a Connecticut Yankee for many years, declared that he counted 136 different varieties of weather in 24 hours one spring.

New England's position on the globe—between 41 and 48 degrees north latitude—explains the extreme, variable climate. Cool, dry polar air from the north bumps up against warm, moist tropical air from both the south and the Atlantic, creating the turbulent weather witnessed often on New England's 6,000 jagged miles of coastline. Ocean currents, too, play a big role in the region's climate, with the arctic Labrador Current flowing down from the north, and the warmer Gulf Stream moving up from the south. When the air riding over these two currents meets, heavy fog can form.

The arm of Cape Cod, extending its sickle shape into the sea, is first to receive these batterings of surf and storm. The Cape is a peninsula of glacial outwash that is constantly being rearranged by wind and sea. The popular summer islands just off the Cape—Martha's Vineyard and Nantucket—are also glacial plains covered with heath plants.

Cape Cod proper grows stubby pitch pines and scrub or black oaks, while the ever-shifting dunes support low-growing beach plum, bayberry, and seaside goldenrod. In the salt marshes, cordgrass, spikegrass, and chairmaker's rush tolerate the saline conditions, and flowers—sea lavender, seaside aster, gerardia, blue-eyed grass, and fleabane—splash the marshes with color. Could the thick salt air have made naturalist John Burroughs think "the wild rose on the Massachusetts coast deeper tinted and more fragrant" than those he was used to?

The Pilgrims managed to endure winter on the coast, learning how to grow corn from the Indians who were already settled and farming there. And, like the Indians, they also learned to "farm" the sea. In fact, the richness of New England's coastal waters was famous long before the Pilgrims landed. The early explorers Verrazano and Cabot chronicled that wealth, recording the North Atlantic's glorious populations of fish, seabirds, and marine mammals. They told of walruses, seals, whales, great auks, and codfish, in abundances that would astound people now. The great schools of cod won the Cape its name in 1602, when Captain Bartholomew Gosnold made his landfall there. He and his sailors found so much cod that after they had filled the ship's hold they threw the surplus back into the sea.

On land, Gosnold and his men searched for the root of

sassafras, in great demand in Europe as a cure for syphilis and other ills. He and others after him remarked—and no doubt dined—on the profusion of strawberries, cranberries, blueberries, gooseberries, currants, and wild grapes that New England offered.

In the midst of such bounty Gosnold may not have noticed, but Cape Cod marks a temperature boundary, with waters colder to the north in the Gulf of Maine, and warmer to the south; temperatures range at least 10 degrees cooler on the north side of the Cape, determining a difference in plant and animal life.

Moving north up the coast, or "down East" as they say, plants begin to change noticeably—from the stunted oaks on the Cape to Maine's stately evergreen forest. Of this more northern coast, author Maitland Edey tells readers they "must imagine one foot always on dry land and the other in salt water. . . . Unlike many seacoasts around the world, the transition here from continental forest to salt water is abrupt. Few dunes or swamps hint that the coast is near—only the smell of the ocean gives away its proximity."

The irregularities of the Maine coast mark it as a drowned coast. The inlets were once river's mouths, now underwater, and the islands, like Mount Desert, are the tops of mountains once landborn. Again, glaciers are responsible, for as they melted, the sea level rose and inundated the coastal plain. The sea has not worn down so quickly the hard rock of this part of the coast, but as authors John Hay and Peter Farb note, "It is all a matter of time."

The dark spruce trees rim the rocky shore and mark the edge of one of the last sizable wildernesses in the East—the "Country of the Pointed Firs." Henry David Thoreau, in his book *The Maine Woods*, found most striking the "continuousness of the forest. . . . It is even more grim and wild than you had anticipated, a damp and intricate wilderness, in the spring everywhere wet and miry." The conifers favor the northeast coast's damp coolness, brought by the icy Labrador Current.

Here is Thoreau writing of Maine in 1846: The forest is full of black spruce, balsam fir, and silver birches. The ground is strewn with moss-laden rocks and lichen. Innumerable lakes and streams—inhabited by salmon and shad and crying loons—are everywhere. Moose, wolves, and bears live in the forests and swamps.

These were the woods Thoreau paddled and portaged through in the nineteenth century, and they are still largely intact. During exhausting canoe carries, mired in soggy ground, Thoreau rejoiced in the country's wildness. He loved the swamps and bogs, and considered them sacred places. "Hope and future for me," he said, "are not in lawns and cultivated fields, not in towns and cities, but in the impervious and quaking swamps."

Maine consists mostly of trees and water. The state's 2,500 lakes and 5,000 streams take up a tenth of its land area. Nearly as large as the other five New England states together, Maine is still 85 to 90 percent forested, despite serious pillaging of the trees by early lumber operators. Thoreau was distressed by the timber cutting, which he equated with an "export of the clouds out of the sky, or the stars out of the firmament." As in much of New England, the hillsides were cut to the quick, and now forests nearly everywhere are second- or third-growth trees.

Botanizing, as he did on all his journeys, Thoreau remarks on the differences he found between the plants of southern and northern New England. In the Maine woods he mentions Labrador tea and Canada blueberry, bellwort, clintonia, snowberry, and twinflower, among others. Ever present is the trademark of these north woods, thick coverings of the bunchberry or dwarf cornel, presenting either typical white dogwood flowers or the brilliant red berries that replace them. A few other wildflowers favor the shady, moist woods, such as the northern white violet, Canada mayflower, and the early-blooming and sweet-smelling trailing arbutus. He also noted an abundant insect inhabitant—the black fly—and observed, "A botanist's books, if he has ever visited the primitive northern woods, will be pretty sure to contain these specimens."

While in Maine, Thoreau set out to climb Mount Katahdin, one of a series of his New England mountain adventures, which included the monadnocks of Connecticut and Massachusetts, the great White Mountain range in New Hampshire, and the Green Mountains of Vermont.

Katahdin, or "Ktaadn" as Thoreau spelled it, is an Ab-

1 5

naki Indian word meaning "highest land" or "greatest moun-
tain." Nestled in the protection of Baxter State Park, the moun-
tain is now the northern end of the Appalachian Trail. To get to
the top hikers must scramble 5 miles over boulders—"a vast
aggregation of loose rock, as if some time it had rained rocks,"
said Thoreau. At the summit a sign points south to Georgia,
2,000 miles. The trail links New England's high woodlands,
through wild places that in this long-used land are beginning
to restore themselves.

The Appalachian Trail almost stopped short of reaching
Maine, ending instead atop Mount Washington in the White
Mountains. Like Katahdin, Washington's summit is above
treeline, and with all such heights, the wind is the strongest
force to be reckoned with. Mount Washington holds the honor
of having experienced the fastest wind velocity known in the
world—231 miles per hour. Gusts are routinely clocked at 100
miles per hour on the peak.

On the way to "New England's rooftop," through birch
and maple and spruce and fir, trail signs admonish that "the
area ahead has the worst weather in America. Many have died
there from exposure, even in the summer." If the weather is
bad, the signs warn, turn back now. And the weather at 6,288
feet, at this latitude, is almost never good. In fact, Mount
Washington is shrouded in clouds and mist most of its days,
and hypothermia threatens the unprepared, even in summer.

Despite its climatic drawbacks, Mount Washington is
"the most climbed, most studied, most lived-on mountain in
the United States, if not the world," says author Ogden Tan-
ner. Along with Katahdin and only a few other places in the
East, Mount Washington holds one of New England's small
but treasured botanical communities—alpine gardens. And
the plants reflect their surroundings. Ann Zwinger and Be-
atrice Willard, in their book *Land Above the Trees*, describe them
thus: "The plants are so cloud-caught that they appear gray.
Green rocks, gray plants: a Norse landscape."

The names of Mount Washington's plant residents be-
speak their northern heritage: Iceland lichen, Greenland sand-
wort, Lapland rosebay. Sedges and mosses and lichens are
most successful in this environment, well-equipped to deal
with the unceasing fog and wind and cold. Among the flowers
one might find during the short growing season are false lily-

of-the-valley, Mount Washington avens, alpine bluet (which
here is white), goldthread, and starflower. As do all arctic-
alpine plants, these survive by adopting compact, low-grow-
ing, furry habits.

New England is in some ways like an alpine plant—
small and compact. Its size and its shared history, both human
and natural, have helped unify it. People have lived for a long
time in their glaciated land, and feel most at home here.
Thoreau could have been thinking of them when he wrote,
"The bird whose eye takes in the Green Mountains on the one
side, and the ocean on the other, need not be at a loss to find
its way."

Robin's plantain

(top left) among maidenhair

fern by Pat O'Hara

1 8

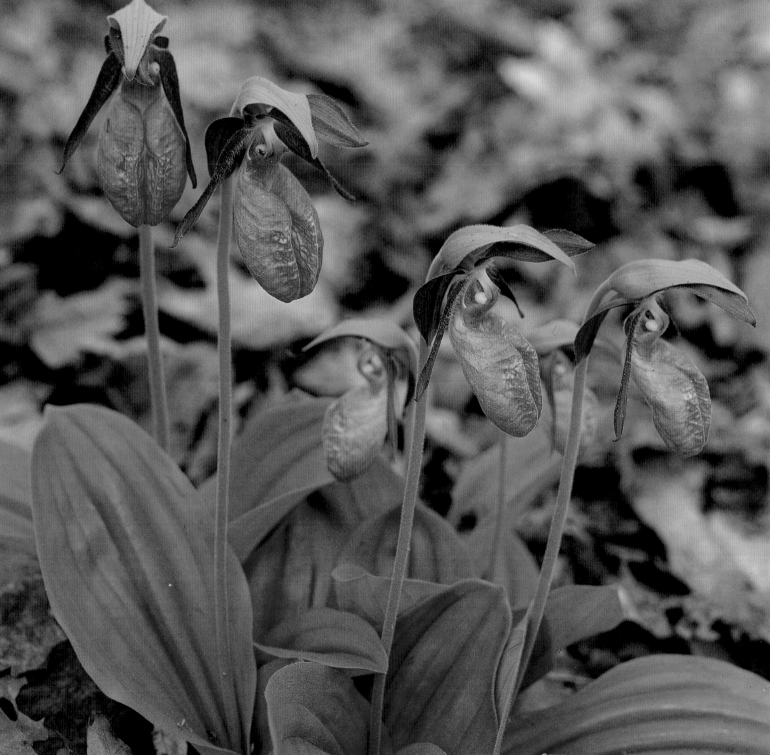

LADY'S SLIPPER

Cypripedium spp.

Without question this slipper is worthy of the feet of Venus, the goddess whose birthplace on Cyprus inspired the name of the genus. Perhaps best-known of all eastern orchids, lady's slipper is wider in range and more flexible in habitat than others of the "royal" orchid family.

The tall stem bears a large graceful flower; some flowers are white, some pink or yellow, and still others are a rainbow of many colors. The lower petal is greatly inflated, like a miniature balloon, and the upper petals are twisted like curled ribbons.

These bright, sweetly scented flowers lure insect pollinators into "traps" that make sure visitors don't leave empty-handed. Should a bee land on the oily lower petal, it slides into the "slipper" and is drawn inexorably down into the flower. Illusory "windows" suggest a way out, leading the bee past pollen-packed anthers. As it squeezes by it is obliged to leave with a basket of golden dust.

The pink lady's slipper, also commonly known as moccasin flower, is found in flower from April through June, both in low sandy woods and in higher rockier areas. Other species, such as the yellow, bloom earlier.

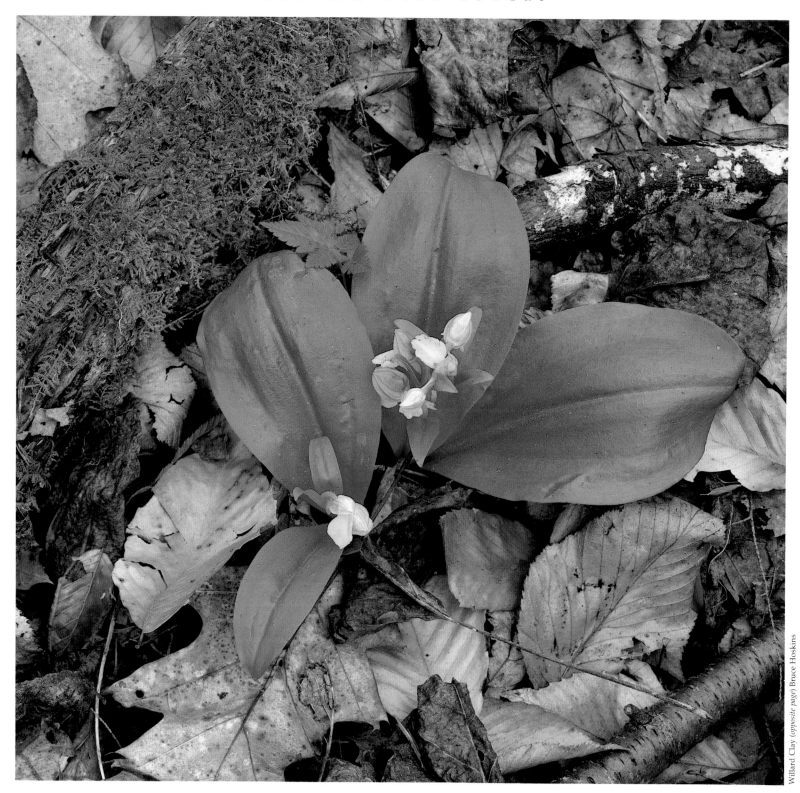

SHOWY ORCHIS & CALYPSO ORCHID

Orchis spectabilis & *Calypso bulbosa*

The showy orchis (*facing page*), though perhaps not as showy as some would expect, is no less beautiful a flower. In delicate shades of pink and white, it may appear in unexpected places—at an abandoned homeplace in late spring, for instance, leading one to wonder whether the family who lived here saw it also, and did it bring them equal joy?

As do all orchids, the showy has three sepals and three petals. Their symmetry is bilateral, that is, one petal differs from the other two in size, shape, or color. In most orchids the lower petal, or lip, is usually the odd one. Rather than separate stamens or pistils, orchids have a center column in which the male and female parts are fused.

Another outstanding orchid beauty is the calypso, or fairy slipper (*this page*). Only one species of calypso—*bulbosa*—is found throughout the world's northern latitudes.

The lovely pink flower grows at the top of a stem that is about eight inches tall. The flower's variegated lower lip, dotted and dashed in brownish purple, has been likened to a sugar scoop or a slipper. The flower does hold the "sugar" that attracts pollinators.

The calypso is elusive. You might spot it in summer mainly in the north woods of New England and northern New York, also as far west as Michigan, Wisconsin, and Minnesota.

2 2

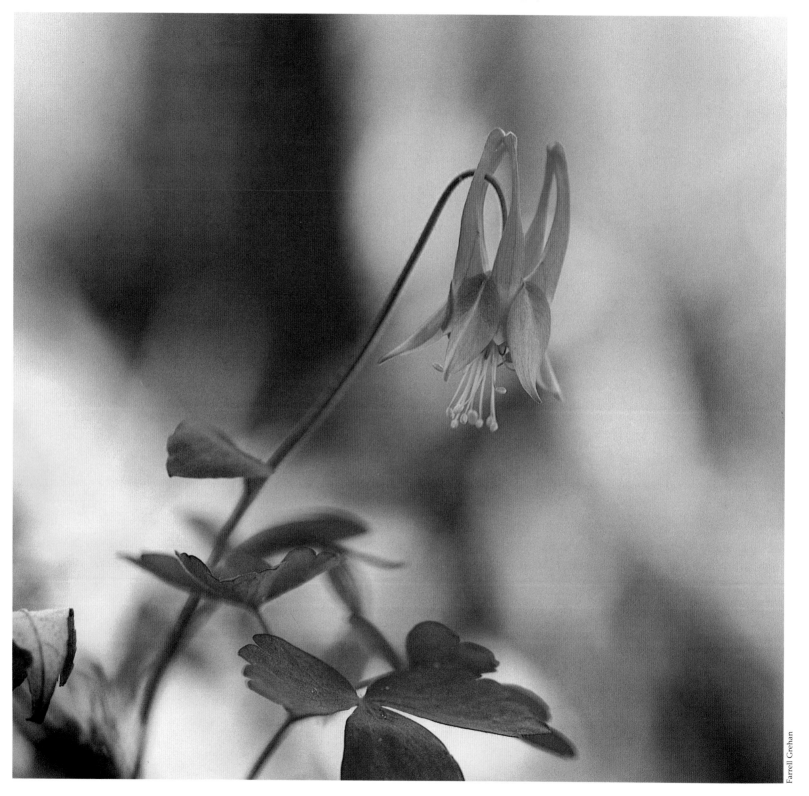

COLUMBINE

Aquilegia canadensis

Columbina, my little dove. So the romantic Italians cooed to someone they loved. In the flowers of the columbine, people have imagined doves drinking from a fountain or a spring. Those "doves," suspended from slender stalks, hold nectar in their knobbed spurs. This treasure of nectar has earned columbine another common name, honeysuckle; and yet another, rock bells, because it tends to favor rocky areas.

Traditionally in shades of red and yellow, wild columbines attract hummingbirds, whose long beaks dip easily into the nectar-rich recesses. Bumblebees too come for the sweets, sometimes nipping open the knob to "rob" nectar and neglecting their duty of gathering pollen from the many stamens.

In religion, art, and literature columbines have enjoyed a long and noble history. In medicine, the plant was thought to remedy everything from plague and scurvy to fever and urinary troubles. Roots and other parts of the plant were boiled for tea, and herbalists mixed the seeds with wine to lessen the labor of childbirth. However, the seeds are now believed to be poisonous.

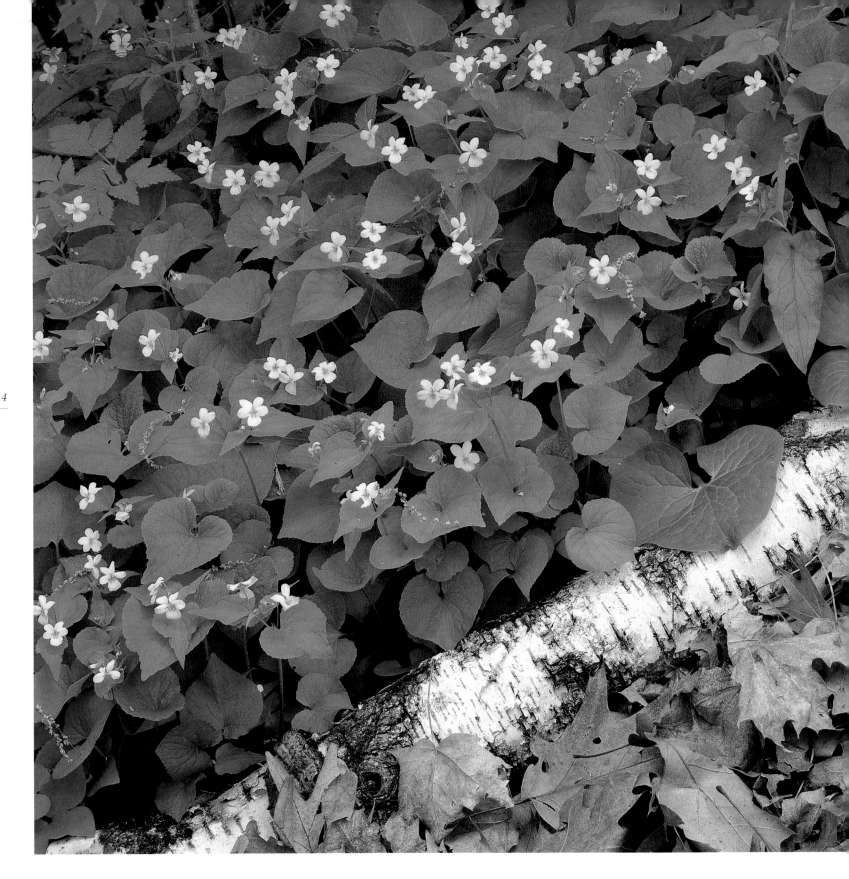

Willard Clay

S W E E T W H I T E V I O L E T

Viola spp.

There are blue violets, yellow violets, green violets, violets that look like birds' feet, and ones that are covered with down. Of the group this simple white violet, sweet and fragrant, is one of the most beautiful.

An old superstition insisted that if less than a handful of violets were brought to a farmer's house, his baby fowl would die. And in early America, violets were considered blood purifiers and were used as treatments for skin diseases and dysentery. The ancient naturalist Pliny prescribed a garland of violets to cure a headache. For a very long time violets have symbolized love and remembrance, and for centuries their distinctive fragrance has been extracted for perfumes. Their leaves contain generous amounts of vitamins A and C and are delicious in spring salads.

The sweet white violet's leaves and flowers are on separate stalks that grow from underground stems. The upper petals of the flower are bent back and twisted; the lower petals are streaked with purple veins to guide pollinators to the stores of food and drink. The flower is cleverly designed so that pollen falls on a bee or butterfly as it reaches into the lowest petal to get nectar.

The seed capsules of violets contain shiny black, perfectly circular seeds that shoot out like beebees once the capsules have dried.

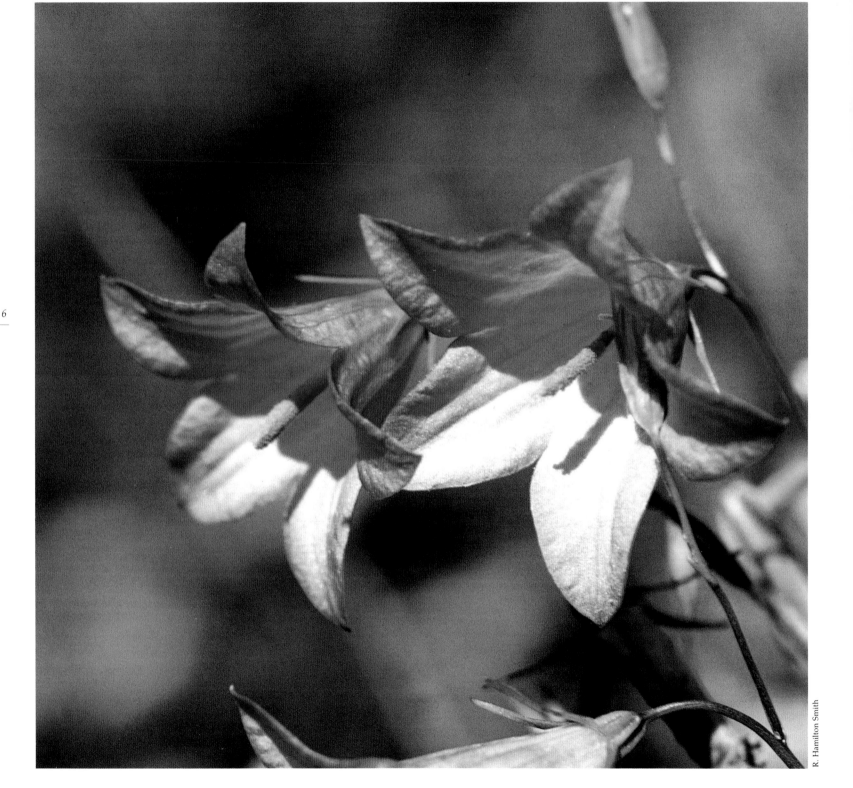

BLUEBELL & HAREBELL

Campanula spp.

A long rocky slopes and in meadows in cooler regions we are treated to the familiar sight of the bluebells. The name, though many different flowers share it, completely describes these bell-shaped flowers. They nod and tremble from the tips of many wiry branches, blue as a summer sky.

Their scientific name, *Campanula*, has a nice ring as well. It dates at least to the sixteenth century, when Leonhard Fuchs applied it to this flower, after the Latin *campana*, or bell.

This plant represents well the potential for communication breakdown that can occur with common names. Take your pick on this one—bluebell, harebell, bellflower, or bluebells of Scotland. But take care not to confuse it with the bluebell of the English, which is a lily, or with the well-known Virginia bluebell, a member of the borage family.

Depending on the habitat, the form of growth can vary. The arctic-alpine plants are small, while taller, larger-leaved ones grow where water and shelter are plentiful.

Folklore tells us that the harebell reputedly possesses magical properties. Certain of its common names, like witches' bells and old man's bells (the devil), reveal these beliefs.

Lung troubles especially could be treated with harebell.

Willard Clay (*opposite page*) Teddy Hoskins

SPRING BEAUTIES & WOOD LILY

Claytonia spp. & *Lilium philadelphicum*

W hat better way to be greeted on an early spring day than by a patch of these peppermint-striped confections? Indeed, one older common name for spring beauties (*facing page*) is good-morning-spring.

The beauties seem to spring from nowhere. Hal Borland recalls that "You could look across a meadow one day and see nothing but greening grass, and the next afternoon that same meadow would be dappled with pink and white—the spring beauties had come to flower."

Covering large areas in fields and moist woods throughout the East, spring beauties appear as early as March and into May. Perennials, they grow from a corm or tuber that, boiled and buttered, is said to taste like a chestnut. Elk, moose, and deer browse the flowers and leaves.

The handsome wood lily (*this page*) belongs to the wide-ranging genus *Lilium*, the one most often associated with lilies. Species in this genus can grow up to nine feet, with the wood lily reaching half that height. The wood lily prefers relatively dry places, offering a dash of red in summer in New England and south into the mountains.

The blossoms, freckled with purple-brown spots, stand erect on the stem, unlike other lilies that hang their heads, supposedly in shame for flaunting their beauty before Christ in the garden of Gethsemane.

3 0

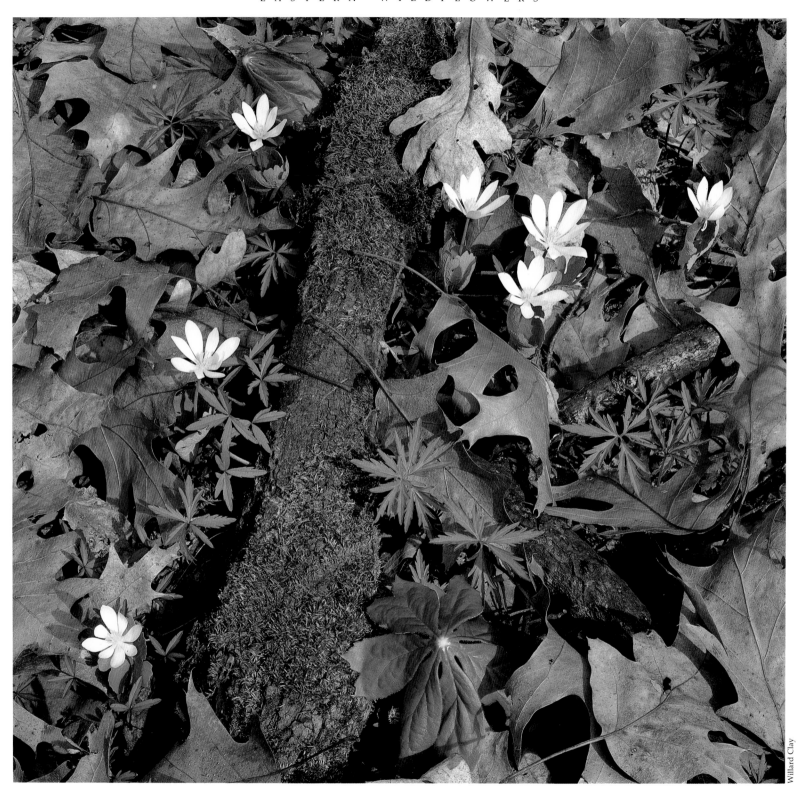

Willard Clay

BLOODROOT

Sanguinaria canadensis

*B*loodroot ushers in the New England spring, blooming in a symphony with anemones, hepaticas, and spring beauties on the rich woodland floor and along streams. When the single flower first rises, it is wrapped in a curled leaf, which it quickly outgrows. The flower is so fragile that one touch can cause the petals to fall to the ground, yet "its very transitoriness enhances its charms," thought Mrs. William Starr Dana.

It may seem curious to equate such a beautiful flower with the thought of blood, but the root, not the flower brought on this name. *Sanguinaria* derives from the word for blood, because the finger-sized fresh root, when cut or broken, oozes an acrid red juice.

To the Indians this plant was red puccoon, or red root, from which they made a body paint, a dye, and a decoction for several ills. The author of an 1895 book on flowers wrote that for coughs and colds he had "taken many drops of its orange-red blood on a lump of sugar." Nowadays, it is recommended that bloodroot be left alone, for too much of its "blood" will bring on vomiting, fainting, and even death.

Edwin Way Teale reports that each year bloodroot consumes part of its root and adds new sections, thus this plant might win immortality.

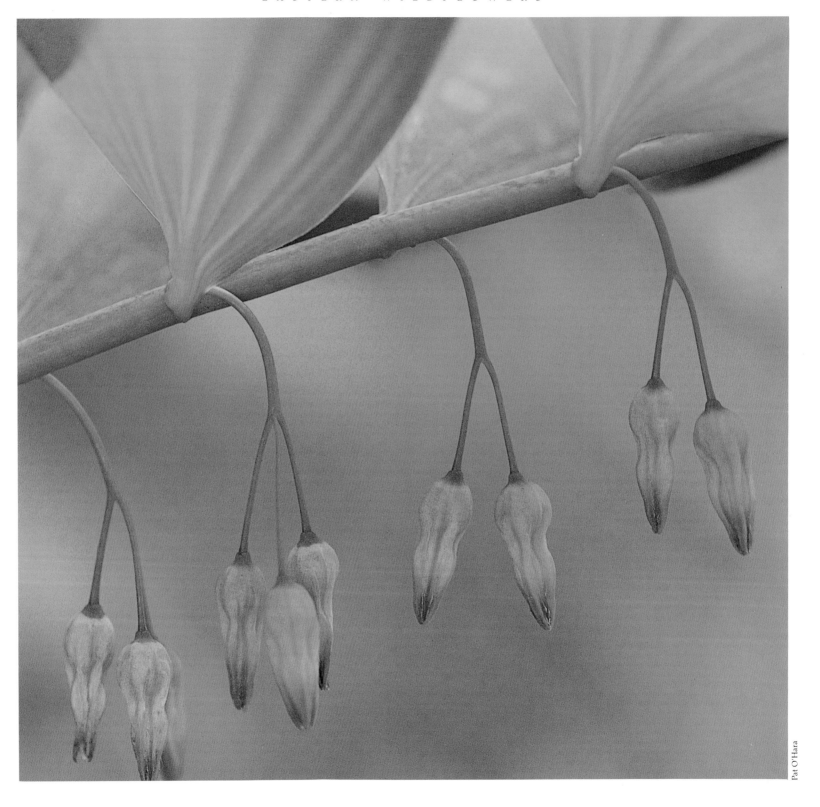

Pat O'Hara

S O L O M O N ' S S E A L

Polygonatum spp.

Like ornaments on a Christmas tree, the flowers of Solomon's seal dangle from gracefully arched stalks. This typical growth style, along with the large, deeply veined green leaves, helps identify this plant of New England's shaded woods.

The flowers may be greenish white or yellowish, depending upon the species; distinctions between species are made by the smoothness or hairiness of the leaves. In autumn the flowers are replaced by bluish berries that look like small grapes.

When the flowering stem dies, it leaves a scar on the rootstock or rhizome. These scars supposedly resemble the official wax seal of King Solomon, who gave the plant's medicinal value his seal of approval. By counting the number of scars on the root we can know the age of the plant—one scar for each year. The genus name, *Polygonatum*, comes from the Greek *poly* for many and *gony*, knee, for the numerous joints on the rootstock.

False Solomon's seal, an entirely different genus and species, is sometimes mistaken for the real thing. But its flowers are clustered at the end of one stem, and the rhizome lacks scars.

Solomon's seal belongs to the huge family that everyone knows and loves, the lilies. From ancient times lilies have symbolized purity and virginity, innocence and good fortune.

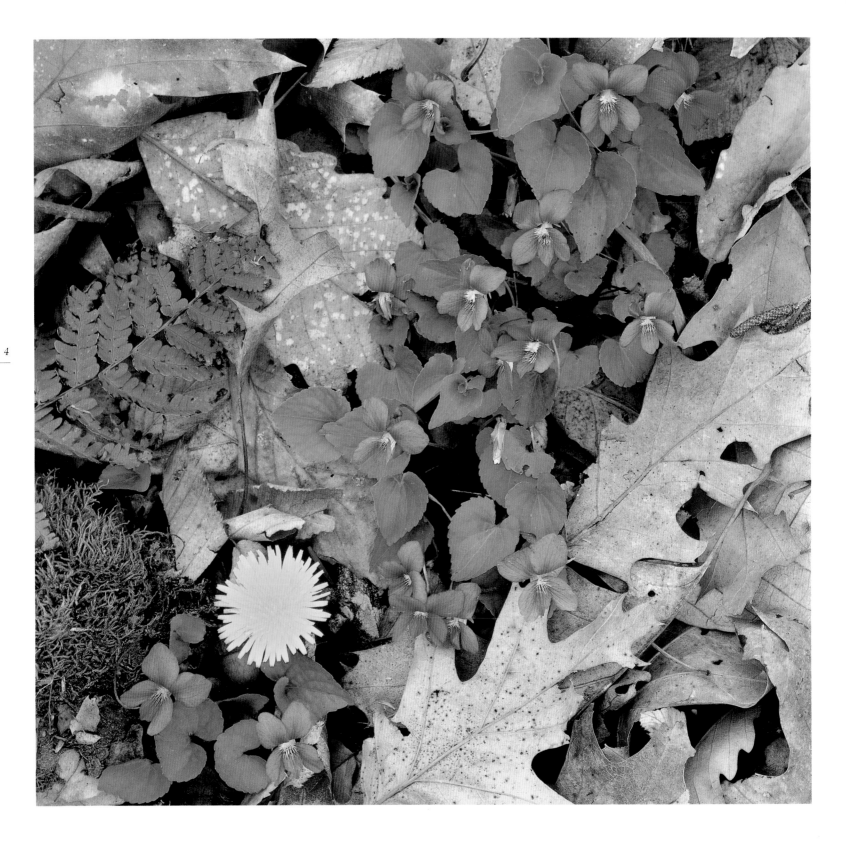

*E*aster Sunday, 1513. The Spanish explorer Ponce de León, at the southern tip of Florida, is so impressed by the lush growth that he anoints the land *Pascua Florida*, in his language, "Feast of Flowers."

If Ponce de León thought the entire continent was so lush, he was mistaken, for South Florida's climate and environment is like no other in the land. Nowhere else are found the twisted tangles of mangrove trees, roseate spoonbills, green turtles, and the portly but lovable manatees. Florida, to many, is the quintessential tropical paradise—the land of coconuts and seashells and alligators.

The entire state is part of the great Atlantic coastal plain sweeping from New Jersey south through Virginia, the Carolinas and Georgia, and arcing west to encompass the bayou and delta country of Mississippi, Louisiana, and Texas. This is low land, at sea level for most of its breadth. The highest point in Florida is a rousing 345 feet above sea level. Though much of the coastal plain remains submerged as sea floor, the level of the Atlantic Ocean has dropped enough to expose all of Florida; the peninsula emerged only about seven million years ago, making it our youngest state, geologically.

White sand beaches, barrier islands, pine woods, and fresh and saltwater marshes and swamps give the coastal plain its character. Soft pines and live oaks, cypress and palmetto trees account for much of the green of the landscape, splashed by the huge magnolia blossoms, the archetypal southern flower. One early traveler, heading south, commented that the "exotic succession of flowers and trees hints of the approaching equatorial sun."

Blue violets and dandelion

(facing page) by Willard Clay,

swamp pink or dragon's mouth

(far right) by Hinke/Sacilotto

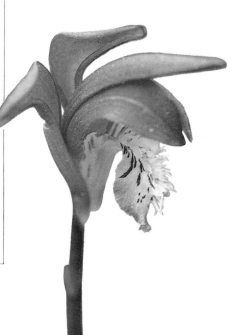

This is flat, humid country, perhaps more inviting as an escape from the rigors of northern winters than as a place to spend a refreshing August. Humidity commonly clings to the 70 to 80 percent range, and summer temperatures easily rise into the nineties.

The coastal plain's uniqueness is revealed clearly in the Everglades of southern Florida. Here, "somewhere south of Lake Okechobee in that no man's land of the seasons," wrote Edwin Way Teale, is a sea of sawgrass savanna, palmetto trees, and hammocks that are home to a bevy of strange plants and animals.

Warmed by the blue waters of the great Gulf Stream, southern Florida boasts a growing season of about 365 days. Flowers of summer and spring bloom side by side in December, as Teale observed. Glades lobelia, clamshell orchids, and swamp lilies are just a few flowers that might be blooming any time of year. Teale and his wife, Nellie, set out in February on a 17,000-mile journey to follow spring north from Florida to Maine. Observing migrating birds and blooming wildflowers, they tracked spring's progress, said to move north at the rate of about fifteen miles a day. In the Everglades, where the Teales began recording their travels, they found that "the perfumes of life and growth" were never absent.

If spring can be said to exist in the Everglades, the bare pale-green haze of new cypress leaves marks the season's arrival. The tops of cypresses are adorned with epiphytes, or air plants, those remarkable aerialists most at home in the highest canopies of tropical rainforests. They include bromeliads, mosses, lichens, and those most visually delicious and rare wildflowers, the orchids. The fantastic epiphytic orchids are known only on this continent in subtropical Florida. The butterfly or ghost orchid is one, so named for the slender greenish-white flower that flashes out from the trees on which it lives. Epiphytes perch high in trees to soak up sunlight, and rather than lapping up water and minerals from soil, they take their sustenance from dew, dust, and the air itself.

Florida's sawgrass marshes stretch like an African savanna to the far horizon. Around pockets of water, often created by alligators, grow white arrowhead, golden canna, blue pickerelweed, and hibiscus. Unlike marshes, swamps are usually more wooded and less sunny. In open areas of dark cypress-tupelo swamps, wildflowers can be found, among them the beautiful but noxious water hyacinth. The hyacinth was introduced to this country in 1884 and has nearly choked off waterways in some areas. Multimillion-dollar control measures—including poisoning, burning, and dynamiting—have been largely unsuccessful in eradicating this plant.

The only break in the startling flatness of the sawgrass "river" are the hammocks, mounds of dry land atop limestone platforms that rise two or three feet above the surrounding terrain. On hammocks in the Everglades tangles of tropical trees and temperate oaks coexist side by side.

The swamps are finely tuned to a cycle of wet and dry seasons. By the end of the normally dry winter, when mudcracks and dry sawgrass make rain a faraway memory, anvil-topped thunderclouds appear on the horizon. Amid a cacophony of bellowing tree frogs, the long-awaited moisture comes. Over millennia the plants and animals have adapted themselves to a complex hydrologic regime.

But things have changed in Florida. Close to downtown Miami, the subtropical wilderness of the Everglades has endured threats from all sides. The "Glades" are the greatest source of fresh drinking water for the many people who surround it. A complicated plumbing network of canals, dikes, channeled rivers, and drained land now controls much of the Everglades water cycle. This tampering has heightened the danger of fire in the normally dry winter months. Though nature intended wildfires in the swamps, the harm to plants and animals can be greater now because the delicate balance of the wet and dry seasons has been set akilter.

North Florida is dry scrub pine country. The panhandle, location of Marjorie Kinnan Rawlings's Cross Creek, holds a special and rather strange treat for flower lovers. Here are lakes with islands that float. Kept buoyant by the gases produced by decaying vegetation, these unanchored rafts of land obey the whims of the wind. They drift to and fro on the water, wafting a heady fragrance and ferrying many kinds of plants. Edwin Way Teale reported walking on one of these islands, then thick with bulrushes, brown-eyed Susans, and buttonberry bushes but later in the year to be covered with blooming loosestrife and fragrant spider lilies, whose heady scent at night would reveal the island's location.

West along the Gulf Coast to Mississippi and Louisiana, we travel through more flat swamp and marsh country. But Cajun names spice this land, which is built entirely of the 400 million tons of silt and debris deposited each year by the Mississippi River.

Over thousands of years the Mississippi has constantly shifted course, depositing at its mouth a delta called a "bird-foot" for its shape. The unending changes in course have given birth to a system of distributaries called bayous (the word is Choctaw for "creek"). Bayous continually form and reform to create a bewildering array of channels and rivers and lakes that merges into land and back into water again. The bayous seem to have trouble making up their minds "whether they will be earth or water," wrote Harnett Kane.

The bald cypress, its knobby knees jutting out of the tea-colored water, is probably the best-known tree of the Louisiana swamps. The fecund water hyacinth wins as most outstanding flower, if only for sheer abundance. In the black delta loam, spider lilies bloom amid impressively large live oaks dripping with Spanish moss. The live oaks are found commonly on ridges called *cheniers* (from the French word for oak). These oaks grow along the beaches where they bear the brunt of tornadoes and hurricanes that strike the bayou country with frightening regularity. From this unleashed violence, however, comes a windfall for plants in the form of rich silt redistributed over the coastal marshes.

There are more than four million acres of marshland in Louisiana, along the Gulf of Mexico and somewhat inland. Their importance to the nation's economic and environmental well-being can hardly be overestimated. They sustain high populations of muskrats, provide rich feeding grounds for ducks and geese, nurse shrimp, oysters, and crabs to edible size, and sponge up precious water for future use.

In salty marshes, salt-loving plants are obviously most comfortable, while in freshwater marshes grow irises, arrowheads, fragrant ladies' tresses, and alligator weed. Transitional brackish areas—partly salt and partly fresh—support plants of both types. Golden club, a bayou plant known locally as bog torch, possesses the curious ability to generate heat when it blooms in spring. It is related to skunk cabbage and Jack-in-the-pulpit, plants that also behave this way.

Adjoining the marshes are treeless prairie areas and treed areas of river bottom hardwoods and cypress that prefer alkaline soil. The pine flatwoods of eastern Louisiana host gentians and indigo, the pinewoods lily, and the carnivorous sundews and pitcher plants.

Heading back east, beyond Florida's panhandle, the coast bends north up the Atlantic seaboard, through Georgia, the Carolinas, and up to Chesapeake Bay. Here the plain reaches its greatest breadth, about 250 miles wide in North Carolina. Between the marshes and the sea is strung a necklace of long slender islands all the way to Delaware. These "barrier islands," running parallel to the coast, are so called because their dunes literally act as walls for the land against the onslaught of the ocean's waves. Like the bayous, their sands are constantly shifting, eroding, and being replenished by new sand carried in by longshore currents. Landward, behind the dunes, are rich pockets of shrubs like chokecherry and jessamine. Brown pelicans and ghost crabs make their homes on them, along with the famous wild ponies of Chincoteague and Assateague islands south of Ocean City.

North Carolina's Outer Banks, of Kitty Hawk fame, are some of the finest examples of remaining wild barrier islands. Even here, though, beach cottages and other developments nudge ever closer to the water's edge, having to learn the hard way that the sea will prevail. Man-made jetties, breakwaters, and sea walls built to protect the structures are like toothpicks in the face of a rampaging storm. Experiencing the onshore winds of February on the deserted Outer Banks is more-than-adequate testimony of the sea's inherent power. Seafarers have long considered this coast a "graveyard." The hulks of battered ships that litter the beaches support their belief.

Inland, beyond the barrier beaches, salt marshes, and bays are dryland pine forests. The East was once famous for these scented forests, which extended from Florida to New Jersey and beyond. Tar and turpentine were extracted by "boxing" the trees, and gave North Carolina the nickname Tarheel State. Longleaf, loblolly, and pitch pines, among others, are now grown like an agricultural crop in parts of the South, not for their sap but for their wood.

Passing the Tidewater country of Virginia and Chesapeake Bay, we enter New Jersey's Pine Barrens, one of the

largest intact pine forests remaining in the country—650,000 acres. The Barrens are located ironically within 30 miles of Independence Hall and 75 miles of the Empire State Building. John McPhee's book, *The Pine Barrens*, is an eloquent description of this anachronism. He tells of the "Pineys" who live in places named Apple Pie Hill, Martha, and Hog Wallow, and who still make livings by harvesting cranberries and gathering sphagnum moss to sell to florists in the city. This is an extremely rich botanical area, claiming twenty-three kinds of orchids alone, including the yellow-crested, white-fringed, helleborine, twayblade, and grass pink.

Through their observations, the Pineys have applied some imaginative names to the plants. The aquatic golden club, the bog torch of the bayous, is here called neverwet, because water will not adhere to the velvety leaves.

In the Pine Barrens, sphagnum moss gives the surface of bogs a quaking appearance, much like the "trembling earth" of Okefenokee Swamp or the southern muskegs in the Appalachians. In these boggy places grow the strange threadleaved sundews, which take their nourishment from insects. Droplets of glue are produced in the ends of the tentacles of sundew plants. When an insect alights on the leaf, the tentacles enclose it and carry it to the center of the plant. The glue acts as an adhesive to keep the insect there until the plant's juices dissolve the victim. Botanists come from far and wide not only to see sundews but also an assortment of ferns, the bog asphodel, the Pine Barrens gentian, and of all things, prickly pear cactus.

Early explorers passed through and remarked upon the extensive pine forests. But the settlers, from John Smith on, viewed the coastal plain as plantation country, where the living was supposed to be easy. Before long, southern drawls would drape like Spanish moss from the live oaks. Tidewater Virginia, the Low Country of the Carolinas, and Georgia were settled by people who found the area hospitable to crops like tobacco. Great rivers—the Potomac, the Rappahannock, the York, and the James—slowed down on the flatland of the plain and became eminently navigable routes to the sea. At one time, coastal plain soils provided almost all the wealth of the South, and, as some told it, a man could farm without a plow.

But the land was soon overworked and worn out. Flowering dogwood now graces the abandoned farmlots each spring. People began to concentrate their industry in the piedmont country. Here, literally "at the foot of the mountains," 220 frost-free days a year made growing cotton feasible.

A line connecting the piedmont cities of Macon, Augusta, Raleigh, Baltimore, and Trenton would trace the "fall line," the eastern edge of the piedmont. Historically, this was the point beyond which ships could not navigate. At the fall line they encountered rapids created by rivers tumbling over resistant metamorphic rock. Herman Clarence Nixon, in his book *Lower Piedmont Country*, describes a place on the Coosa River called the "devil's staircase," where the roar of the water could be heard for miles. "Here," he said, "was the final leap from uplands to lowlands."

The coast and the piedmont were the front lines of civilization in this country. To their back was another territory, which remained a formidable barrier to settlement for a long time. Once penetrated, however, the wonders of the forests of the Appalachian Mountains became an instant lure—to different sorts of people. Their cool green heights have become a destination for city-weary vacationers, offering soothing refuge. Had Ponce de León seen these mountains at Easter time, their feast of flowers might have earned for them the name *Pascua Florida*.

Rose mallow (facing page)

by R. Hamilton Smith

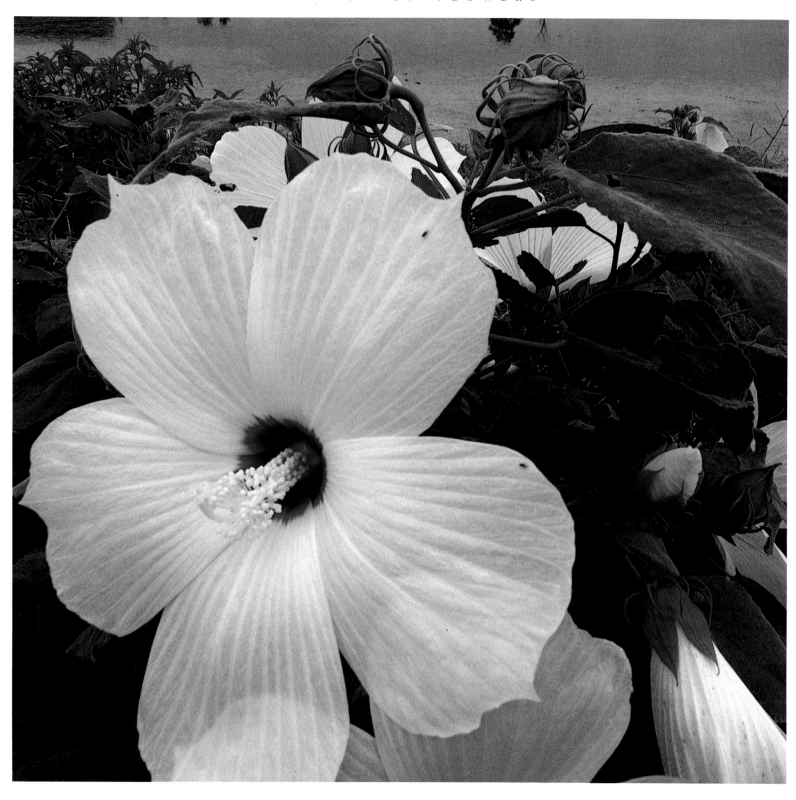

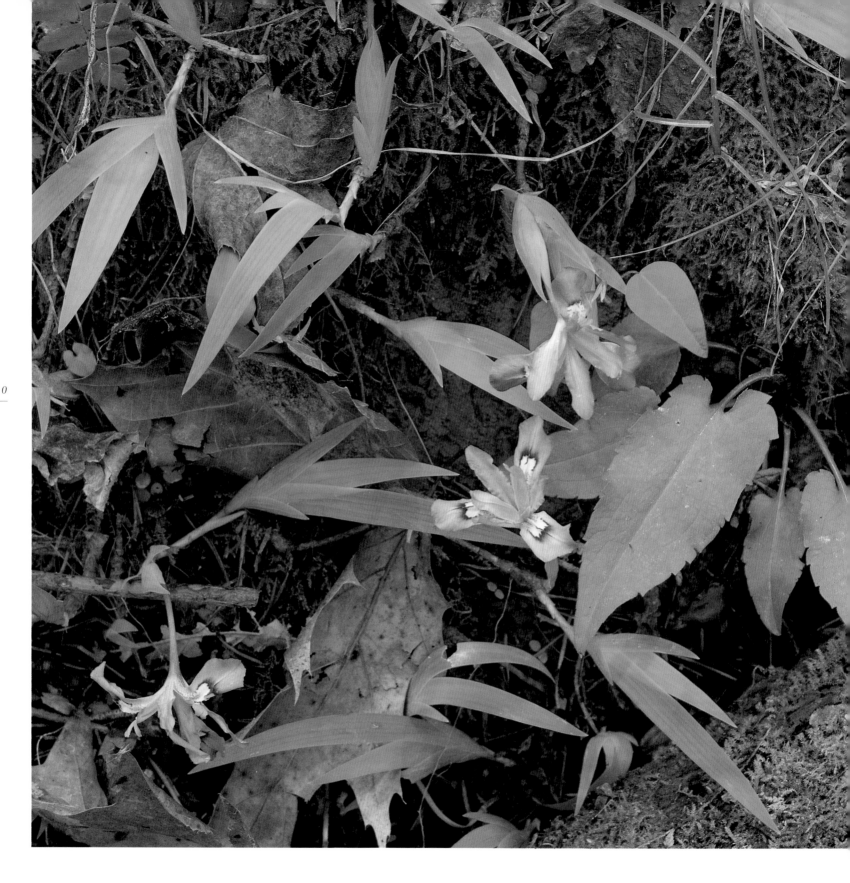

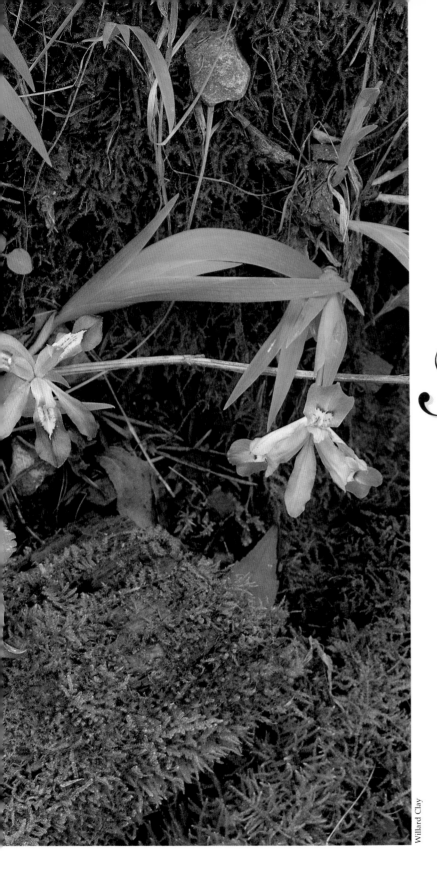

D W A R F I R I S

Iris spp.

Though small in stature, dwarf irises are among the most ravishing of spring wildflowers. One species, the fragrant *Iris verna*, prefers peat soils and pine barrens, while the dwarf crested iris is found in the lower elevations of the mountains. The "crest" of the dwarf iris consists of ridges of fine hairs on the streaked sepals.

The leaves of these low-growing irises are narrow and grasslike, borne on slender rhizomes that grow on the surface of the ground. The plants vary from two to eight inches in height, and each flowering stem usually bears only one blossom.

Christian Conrad Sprengel, the father of pollination biology, studied irises and found that they rely almost exclusively on bees and bumblebees for pollination. Other research has shown that the color combination of irises, yellow and blue, falls within the four broad categories of "bee colors," those colors visible to these insects.

Iris was the goddess of the rainbow, whose job was to escort women's souls to the Elysian Fields. Juno, the protectress of women, was so impressed with Iris she named a flower for her, one that would contain the colors of the rainbow. In poetry, the three flower parts typified wisdom, faith, and courage. Louis VII adopted the iris as the fleur-de-lis, a symbol of France's victory in the Second Crusade.

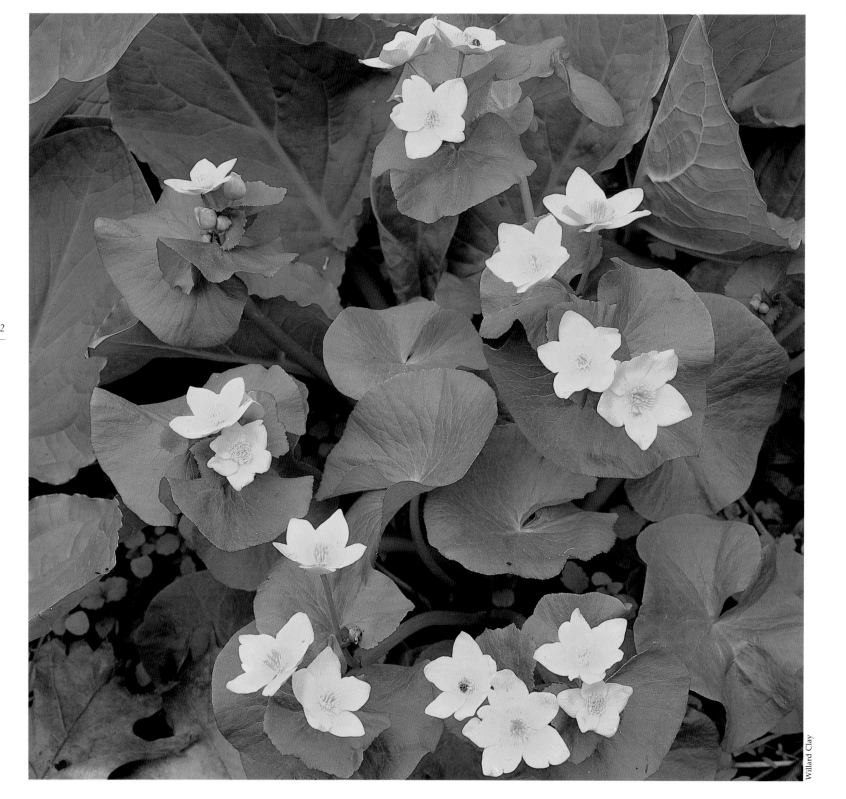

42

Willard Clay

M A R S H M A R I G O L D

Caltha palustris

D ifficult to miss with its gleaming sepals, this member of the buttercup family blooms in big clumps in April. Hal Borland warns that we have to get our feet wet to see them, but they are worth it, "for they are the purest gold that spring provides, a breathtaking golden-yellow."

Like most in the family, the marsh marigold has waxy, shiny sepals. The epidermis of buttercup flowers contains a yellow oil underlain by a light-reflecting layer of starch cells that acts like the white paper used by a water-colorist. The combination produces brilliant color.

Marsh marigold is often called cowslip, a name that is derived, we might add, from cow slop. But the marsh marigold bears no resemblance to the cowslip of England and Europe, a common primrose. Neither is it related to marigolds, though the Anglo-Saxon heritage of that common name traces to a logical corruption of "marsh-gold." In Latin, the name translates as cup (*Caltha*) of the marsh (*palustris*).

Boiled in several waters, the large leaves are good potherbs, possibly better than spinach. Don't eat them raw— they do contain poisons.

In Ireland, marsh marigolds were hung in windows on May Day to ward off unfriendly fairies.

44

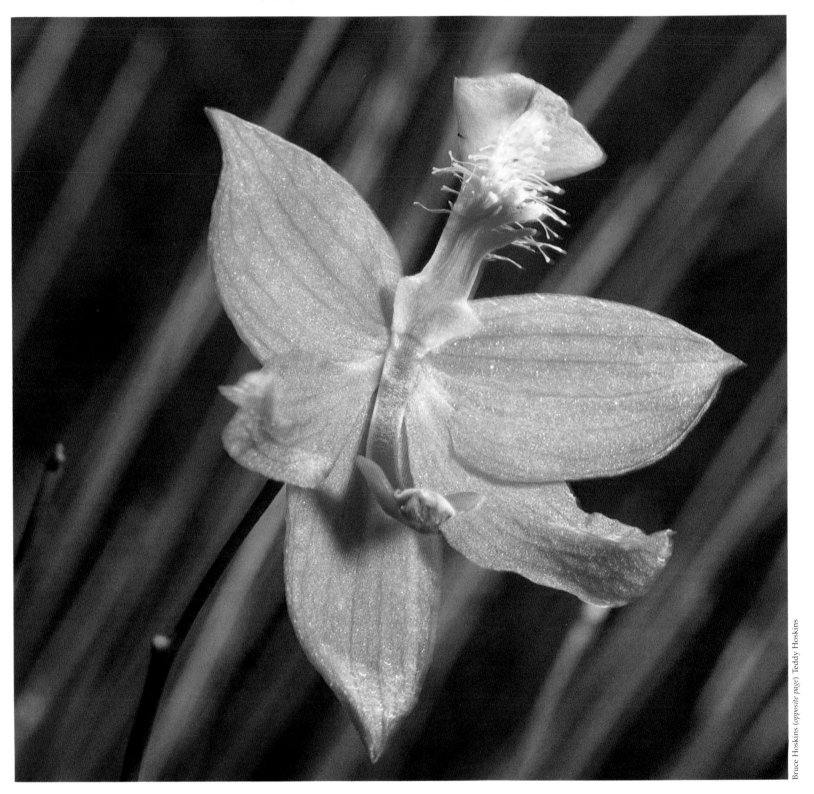

GRASS PINK & ROSE POGONIA

Calopogon spp. & *Pogonia ophioglossoides*

The genus *Calopogon*, the grass pink (*facing page*), is from the Greek for beautiful beard. We can identify this fascinating orchid by the yellow-bearded lip petal that stands above the hot pink sepals and petals. Unlike most orchids, the lip petal of grass pinks assumes the upper, rather than lower, position. This unique structure makes it easy to distinguish this orchid from other similarly colored species.

The beard is cleverly disguised as a bunch of pollen-bearing stamens, leading pollinators to anticipate a feast. When a bee lands on the hairs, the lip throws it down on the curved column, where it contacts the sticky pollen masses called pollinia.

You will find grass pinks in bogs and bog meadows, on acidic, sandy, or gravelly sites.

Another species named for its "beard," or pogon, is the rose pogonia (*this page*). It is the only species of its kind found in this country. Rose pogonia, or snake mouth, grows in the East along the coastal plain as well as inland in sphagnum bogs, glades, and other wet areas. A botanist writing in 1880 noted that it grows in places so wet "that those who go out . . . in patent leather shoes have generally to be satisfied with admiring from a distance."

Some say rose pogonia smells like violets or raspberries. Henry David Thoreau, perhaps influenced by the common name, thought it emitted a "snaky odor."

4 6

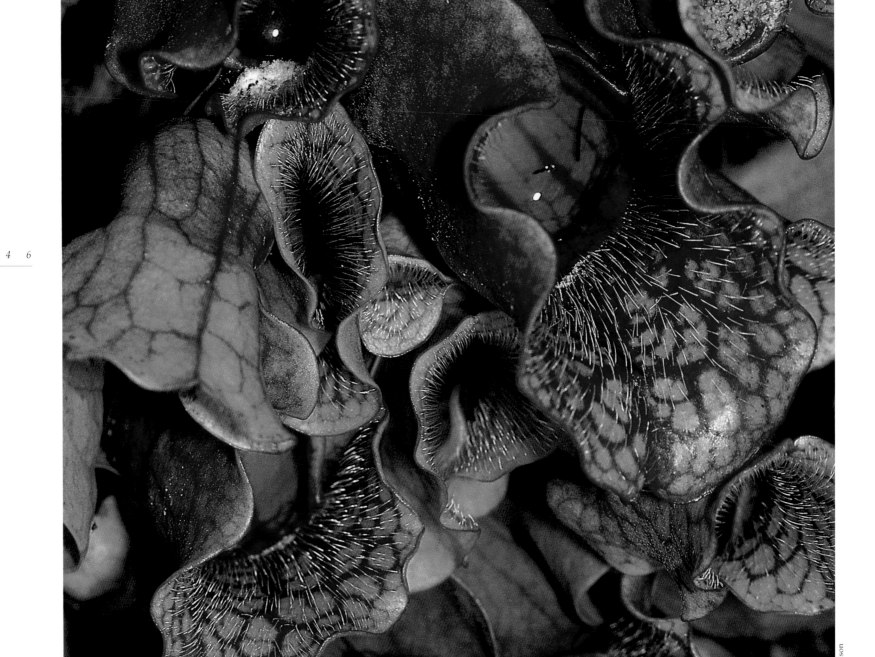

PITCHER PLANT

Sarracenia spp.

The great botanist William Bartram had trouble believing that pitcher plants actually draw sustenance from insects. Bartram, exploring the eastern seaboard in the late eighteenth century, described these botanical curiosities but did not accept that they were truly carnivores. Perhaps the notion was to him, as to many people, just too alien.

But pitcher plants, or trumpet pitchers, as they are sometimes called, do in fact eat insects. They catch them by means of a pitfall trap. Insects, attracted by a plant's scent and color, find nectar glands covering the outside of the trumpet. At the mouth of the pitcher, the nectar concentration is greatest but the footing is tenuous—visitors suddenly find themselves falling irretrievably into a pool of fluid at the base of the pitcher. Hairs that point down prevent their escape and they drown. The plant releases enzymes and acids that decay the victims, slowly digesting them and absorbing the nutrients they provide.

All but one species of pitcher in this country grows in the East, always in acidic, boggy, and often peaty soils poor in nitrogen and other essential plant elements.

Though the leaves are perhaps the more interesting part of the plant, the flowers are also striking. They are usually red or yellow, sometimes quite large, and some exude a pleasing scent.

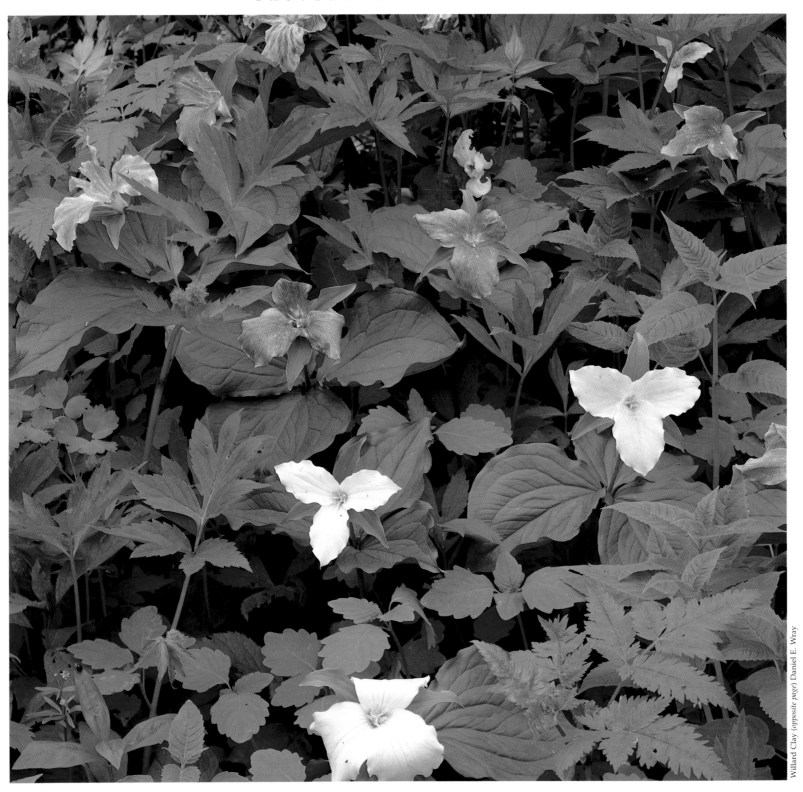

Willard Clay (*opposite page*) Daniel E. Wray

TRILLIUM & WATER LILY

Trillium spp. & *Nymphaea odorata*

*P*erhaps no other wildflower evokes "eastern" as well as the trillium (*facing page*). These readily identifiable flowers grow nearly everywhere, under nearly every condition, in varieties of scents, styles, and colors. Some trilliums are stemmed, others are not, and they can be purple, pink, white, and yellow, though the whites can fade to pink as they age, as in the photograph on the facing page.

Trilliums are lilies, which explains the characteristic three-part harmony. In the trillium, all parts of the plant appear in threes: the sepals, the petals, and even the whorl of leaves that cradles the flower.

One species that grows in the Piedmont, Catesby's trillium, is named for a famous English naturalist, Mark Catesby. Another, the purple trillium, emits what to us is an unpleasant scent. Flies, however, seem not to mind, since they pollinate this species.

The water lily (*this page*) is the essence of peace and serenity. Floating on tranquil water, their fragrance filling the air, they inspire meditation appropriate for a lazy summer day. Once fertilized, the flowers are literally pulled underwater until the seeds mature. They then rise to the surface, where they can float away and then drift down into the muck of a pond bottom, a new germination site.

5 0

A T A M A S C O L I L Y

Zephyranthes atamasco

Though it is often called Easter lily, and looks much like a lily, this is not a true member of that great family. Most botanists now place the atamasco lily in the amaryllis family, due to the position of the ovary. It is said to be "inferior," because the floral parts are attached above the ovary rather than below.

Atamasco lilies prefer damp meadows, glades, and moist soil in pine woods, habitats abundant in the coastal plain and piedmont. They are found from Virginia south to Florida, and over to Mississippi, Louisiana, and Texas; they do bloom around Easter time, hence the previously noted common name.

They grow low to the ground, from bulbs that resemble onions, though without the odor. Like most in the amaryllis family, the bulb is poisonous. The stupendous white to pink-tinged flowers can be up to three inches long.

Atamasco comes from an Indian word for "stained with red," perhaps for the pink tinge of the buds and flowers. Zephyr lily is another name for them, for Zephyrus, the west wind, who was the husband of Chloris, the goddess of flowers. The zephyrs brought fair weather from the west in the spring.

In western North Carolina, where they are rarely found, the Cherokee called them *Cullowhee,* for which a town there was named. Our gardener-president Thomas Jefferson admired them so that he planted them at Monticello.

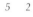

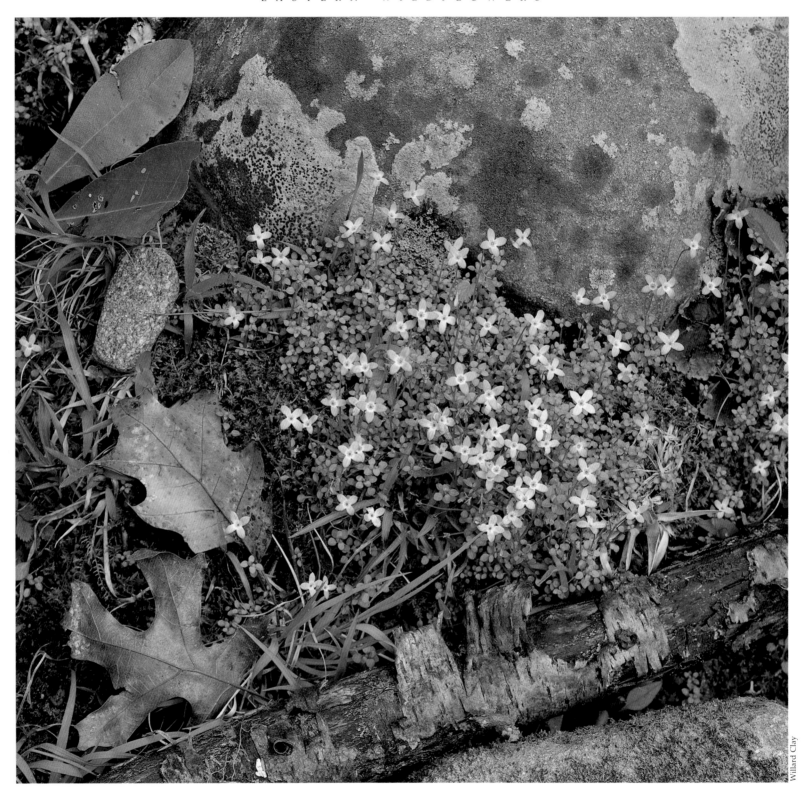

Willard Clay

B L U E T S

Houstonia spp.

*I*n open fields and on grassy slopes bluets put on a show in the spring, sometimes turning an entire hillside blue. Notes Harold William Rickett, "This small plant rejoices in at least a dozen names in English." They seem to look up with bright eyes of yellow, making two of their other common names—innocence and Quaker ladies—perfectly appropriate.

Bluets overwinter as a small rosette of leaves on the ground. As the flower buds open in spring and early summer, they arise from their bowed position and stand upright. At night each flower closes, then reopens each day for the month or so that it blooms.

The flowers are of two kinds—one with short pistils and long stamens (male), the other with long pistils and short stamens (female). Only one type of flower grows on a given plant, thus assuring, or at least encouraging, cross-pollination.

The great Swedish botanist Linnaeus named the genus in honor of Scottish surgeon William Houston. Houston collected in the early 1700s in Mexico and the Caribbean, but did not himself send home bluet specimens. Nevertheless, Linnaeus for some reason saw fit to name this flower after him.

These charming flowers are part of an interesting family, the bedstraws, including plants from which coffee, quinine, and madder are obtained.

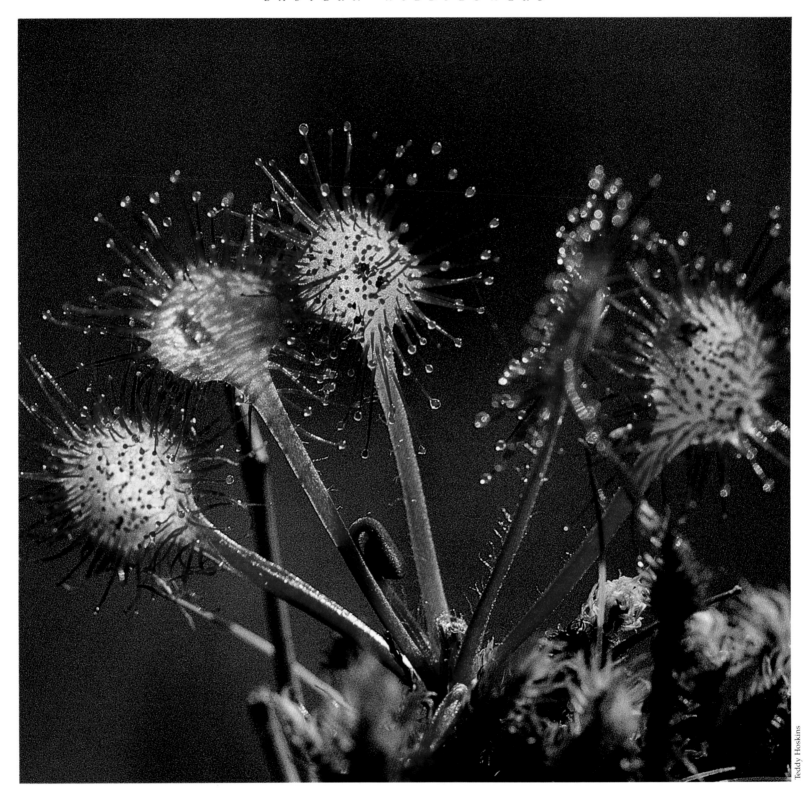

S U N D E W

Drosera spp.

A long with pitcher plants, sundews are good alternatives to flypapers and flyswatters. They too are carnivorous but employ even more active means to snare their prey than do the pitcher plants.

They are indeed like flypaper. Their leaves are covered like a pincushion by tentacles tipped with sticky drops of mucilage. Insects that land on the plant are caught in this glue. In Latin the plant is *Ros solis*, the dew of the sun, for the way the drops sparkle, and the Greek name *Drosera* comes from the word for dewy.

Though his grandfather had hinted at it, Charles Darwin finally proved that these plants are carnivores, trapping then digesting insects. Sundews actually move to capture their prey. Depending upon which part of the leaf an insect lands on, it will either be held by the glue and tentacles or the leaf will roll around the insect and move it to the center of the leaf. Over several days the sundew remains closed while the insect is being assimilated. Sundews react to the slightest pressure on the tentacles, but seem able to distinguish between edible and inedible material.

In the East, various species of sundew can be found on the coastal plain, the round-leaved and thread-leaved being better known. All grow in nitrogen-deficient soils, usually in bogs and wet, sandy areas.

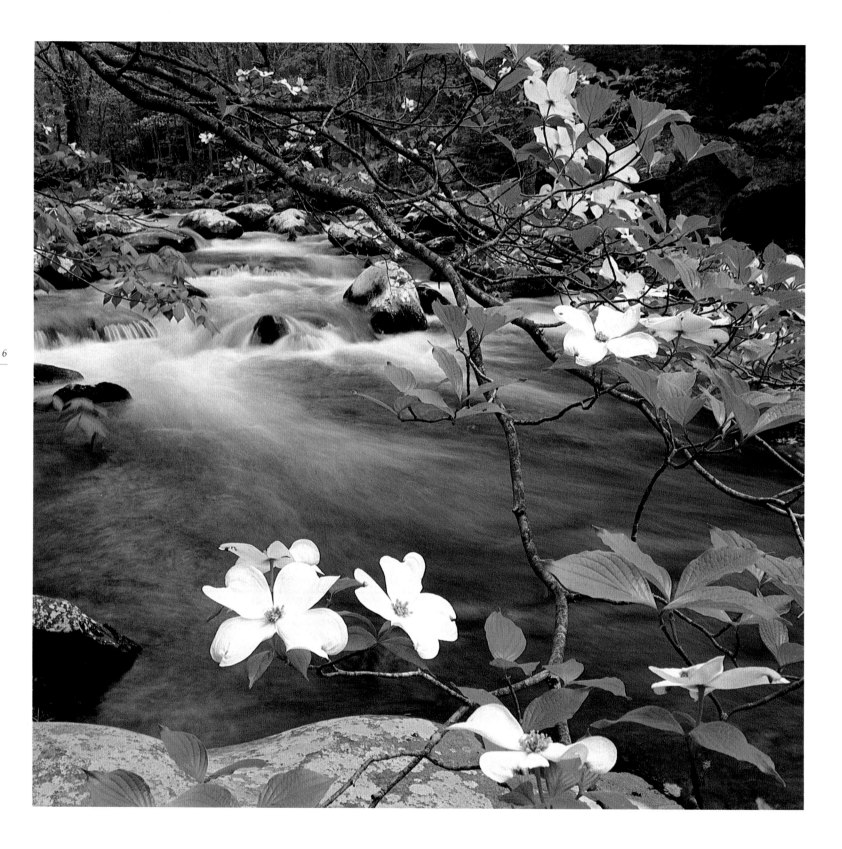

*L*ord, 'tis a pleasant thing to stand in gardens planted by Thy hand."

This inscription was etched on the gravestone of an early American naturalist, one who might well have stood in the flower gardens of the Appalachian Mountains.

Among the glens and balds and coves of these great old mountains of the East are found some of the finest and most interesting flora anywhere in the world. A surprising number of wildflowers grow only in these mountains, others will be recognized by New Englanders, Southerners, and Midwesterners alike, while some might be more familiar to a botanist from Asia. In Great Smoky Mountains National Park alone, some 1,500 species of native flowering plants have been identified.

The coming of spring to the Appalachians has, with good reason, inspired composers to write music in celebration of the season and the flower show that comes with it. Author Jerome Doolittle describes it this way: "When wild flowers begin to bloom in early spring the higher summits emerge from the snow, frost and fog of winter to become as colorful as a crazy quilt." A blanket of flowers—azaleas, orchids, and hundreds of thousands more—decorates the lower reaches of the mountains in April, progressing to the higher peaks in May. So famous is the spring blossoming that Great Smoky Mountains National Park has for more than thirty years staged an annual wildflower pilgrimage at the end of April.

In spring redbuds and dogwoods paint the mountains in bright pink and starched white. The singular flowers of blood-

Flowering dogwood (facing page) and

violets (far right) by Pat O'Hara

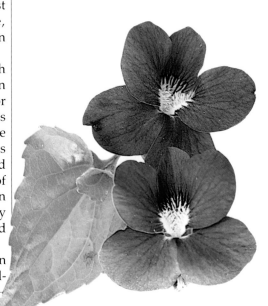

root poke through the duff of the forest floor, and prim little spring beauties carpet the ground. Whole hillsides are covered with gargantuan trilliums. Jack-in-the-pulpit, England's cuckoo pint, is "known to all who love the woods in early spring," wrote Mrs. William Starr Dana in her classic early-twentieth-century wildflower guide. Summer and fall hold their own as fine wildflower seasons too, and even into October goldenrods and purple asters paint the roadsides with their complementary colors.

This vision of the Appalachians as flower garden was not always so. During the nation's infancy the backbone of the East was a formidable barrier, blocking settlement of the lands beyond to those already crowded on the coastal plain. Daniel Boone, the undaunted frontiersman, expressed his feelings upon facing Cumberland Mountain. "The aspect of these cliffs is so wild and horrid that it is impossible to behold them without terror."

But wanderlust was a stronger motivation, and in 1769 Boone crossed Cumberland Gap, in the far southeast corner of Kentucky. Though he was not the first white to see the gap, Boone's clearing of the Wilderness Road from Virginia into Kentucky blazed the path for a wave of pioneers that followed. Up in the "hollers," where settlers built their log cabins, a way of life unique to these mountains was created, a life viewed as poor by modern American standards but one that has left us a rich legacy of folklore, music, and craft.

In their entire length, the Appalachian Mountains stretch northeast to southwest for some 1,500 miles, from Newfoundland to Georgia. For now, we will consider only the central and southern parts of the range, from New York to north Georgia. These are very old mountains, as told by their soft rounded shapes, actually the remnants of a mountain range that was once much taller. Erosion has been gnawing at them for a long time. Geologists talk about "Old Appalachia," represented by the 1,100-million-year-old metamorphosed gneisses found in the Shenandoahs and the Blue Ridge, considered by many the heart of "Old Appalachia."

West of the Blue Ridge lies the Great Valley and associated ridges and plateaus—"New Appalachia." Found here are younger sedimentary rocks brought to the surface during the Appalachian Revolution, some 300 million years ago. The long period of earth history preceding this upheaval was the time in which Appalachia's prodigious coal seams were deposited. More than any other natural resource except trees, coal has shaped Appalachia's history, economy, and society.

But the Appalachians are not so much one mountain range as many. There are the Alleghenies, the Blue Ridge, the Catskills, and the Unaka chains. At 6,684 feet, Mount Mitchell in western North Carolina is the highest peak in the Appalachians, and in the eastern United States for that matter. Also known as Black Dome, the mountain's official name honors Professor Elisha Mitchell, who died in 1857 on the mountain. All the high peaks in the Appalachians are cloaked in a thick mantle of deciduous trees, with isolated stands of spruce and fir at the very highest elevations.

The relative absence of bare jagged peaks, such as those of the Rocky Mountains and other western ranges, should in no way deceive a person as to the ruggedness of the Appalachians. Throughout, their exceedingly steep slopes and dense undergrowth present plenty of challenge to those who elect to explore them. One native put it plainly: "Goin' up, you can might' nigh stand up straight and bite the ground; goin' down, a man wants hobnails in the seat of his pants."

And walking is a traditional way to get around these mountains, especially along the route known as the Appalachian Trail—the "AT" to its admirers. Along its 2,000 miles from Springer Mountain in Georgia to Mount Katahdin in Maine, the AT offers the foot traveler the best—and sometimes the worst—the mountains have to offer.

Hiking even a short distance on the AT will take you into the spruce-fir forests of the high peaks, the diverse hardwood forests of the lower elevations, through gaps and steep river gorges, and up on the treeless balds. When the mountains aren't engulfed in clouds or fog, the panoramas from the path display the trademark of the Appalachians—ridge after ridge after ridge rising higher and higher into the distance through a dreamy blue haze. You might also see a black bear's claw marks on the wall of an AT hut, or be serenaded by the sweet strains of a banjo wafting from a cabin on an early morning. Expect exhausting hikes up slopes so steep that you must bend forward to keep the weight of your pack from pulling you backward. And if you are lucky, you may be rewarded on

a dry day by a meadow overflowing with white and blue and yellow flowers, nodding and smiling, mocking your tired muscles and uplifting your spirit.

In 1794 French botanist André Michaux was so elated when he reached the top of Grandfather Mountain in North Carolina that he belted out the Marseilles Hymn and cried "Long live America and the French Republic! Long live Liberty!" The exuberant plant man collected assiduously and sent his specimens to the Jardins des Plantes in Paris. One of his species, the frilly Oconee bells, was not found by botanists for another century. This and other plants like Buckley's phlox, box huckleberry, and Fraser's sedge are counted among Appalachia's "lost" plants that have now been found.

Besides these, the mountains harbor a wealth of orchids, the elite members of the flower world. Though not as remarkable as the variety known in the tropics, Appalachia's orchids are great attention-getters wherever they are found, especially the rarer and showier ones. Their beauty and desirability has endangered many of them, due to overzealous collectors. Botanist Maurice Brooks mourns that in his lifetime three of the four sites in West Virginia for queen lady's slippers have been destroyed by people who dug up entire colonies for their gardens. And all the plants died after being moved from their native homes, says Brooks. Nevertheless, a conscientious botanophil will have no problem observing orchids in the mountains, from the well-known lady's slippers to round-leaf and showy orchises, rein orchids, calypsos, and swamp pinks.

The Appalachians possess an impressive number of flower species that are exclusive to these mountains. Some forty wildflowers, among them the Oconee bells and the lovely white-fringed phacelia, occur nowhere else in the world. The closest relatives of some of these endemics, as they are called, are found in faraway Asia. They obviously share the same ancestors, but what explains their present separation? Botanists think that 65 million years ago a land bridge connected the two continents, and similar plants extended in a forest belt from southeast Asia, into Alaska, and down to the southern Appalachians. Subsequent shifts in the continents and differences in climate over millions of years isolated them from one another.

Visiting botanists almost always want to see those cu-

rious features of the southern Appalachians called balds. The existence of these meadowlike clearings in the saddles of the mountains remains a mystery, but meanwhile anyone can enjoy their sumptuous wildflower displays. Edwin Way Teale wrote that, "In May these lofty meadows bloom with wildflowers as though they were pieces of prairie lifted thousands of feet into the air." Violets, bluets, and cinquefoil are some of the plants he recorded on Siler's Bald in the Great Smokies. He noted there too a "cloud spring," fed by water squeezed only from the daily fog.

Others have also remarked on the similarities between these treeless areas and prairie. In the Smokies, 125 different plants have been found on grass balds, but the dominant plant is mountain oat-grass. Historically farmers took their livestock up on these balds to graze. What makes ecologists wonder about them is that the balds keep their grassland character, even though the climax plant community in these mountains is forest.

There are eighty or more balds in the southern Appalachians, from a quarter of an acre to a thousand in size, and many of them face east. Hot, dry southwest winds might explain them, though others have proposed ice, fire, or insect damage. Or they might have been Indian clearings, though the Indians of the region maintain their own explanation for balds—they are places where a giant planted his feet, stomping grounds of the devil.

Another type of bald is covered with heath plants, the brilliant rhododendron, wild azalea, and mountain laurel shrubs for which the Appalachians are duly famous. Mountain folk call these heath balds "slicks," for the gloss of the evergreen leaves, or "hells," because they are impenetrable to those on foot.

Heath plants thrive on acidic soil and can withstand the exposures of their high-elevation habitats. Gorgeous pink bouquets of Catawba rhododendron, another Appalachian endemic, spangle the shoulders of the mountains in June. They are especially abundant on Roan Mountain in a place called Cloudland Rhododendron Gardens. The pink tint the flowers give to the ridgetops was said by the Cherokees to be the blood of their ancestors who were killed in battle. Wordsworth, sight unseen, wrote poems about them: "flowers that

with one scarlet gleam/Cover a hundred leagues, and seem/To set the hills on fire."

As unique as balds, but for different reasons, are the coves. In spring, before the leaf canopy shuts off sunlight, coves are resplendent wildflower gardens. But cove trees perhaps merit even greater attention. Tucked near the feet of the mountains, these valleys of deep, rich soil shelter a diversity of hardwoods rare in the world. A few isolated coves still contain virgin trees that show all too vividly what early settlers found in the Appalachian Mountains, before plow and axe were applied. Seeing oaks almost 100 feet high and tulip poplars towering nearly 200 feet can border on a religious experience for some people.

Cabinetmakers and lumbermen marvel at the assemblage of tree species from throughout eastern North America, all growing in one complex. Walnut, maple, oak, cherry, magnolia, buckeye, locust, crabapple, redbud, dogwood, tulip poplar, and serviceberry, to name only a few. Twenty-five or thirty kinds of flowering trees alone can be found in the coves.

Sightseers throng to view this treasure of hardwood trees, when they are in full fall attire, in late September and October. They are privileged to be seeing one of the greatest deciduous forests, both in extent and diversity, in the world. In fact, the onset of cold weather in this temperate region decides the deciduous nature of this forest. Winter is a time of drought for these broad-leaved trees, and only by dropping their leaves can they survive it.

The nature of this forest also determines what wildflowers grow on its floor. In earliest spring the flowers with buds already formed the previous year are ready to bloom when the soil is warm enough. These are perennials, that grow from thickened underground bulbs or corms or rhizomes. Hepatica, bloodroot, spring beauty, and Dutchman's breeches are among them. Then, as the tree buds begin to unfurl, prime flower time begins. Short-lived, these flowers must bloom and produce seed before tree leaves exert their full shading power. Through May and mid-June the show continues, but by then the only flowers persisting are those that can tolerate shade or that live in clearings.

Moving from the southern Appalachians into the lower central mountains, we find other fascinating botanical niches.

From Pennsylvania into Virginia, but mostly in the Alleghenies of West Virginia, are areas known locally as "glades." These are the southern muskegs—swampy woods and open marsh that harbor plants and animals at the farthest southern limits of their ranges. According to botanist Maurice Brooks, places like Canaan Valley and Cranberry Glades in West Virginia are "natural refrigerators." The glades, says Dr. Brooks, are a "gift of the Ice Age," planted when the glaciers were pushing south. In most places the plants and animals retreated with the glaciers, except in the bogs. Because of the natural insulation furnished by sphagnum moss, they could resist the warmer climate surrounding them.

Along with the moss occur bunchberry, buckbean, bog rosemary, dewberries, reindeer moss, and orchids. And as in bogs almost everywhere, the insect-devouring sundews, bladderworts, and pitcher plants find plenty of nutrition. With few exceptions, nearly every common wildflower found on Mount Washington in New Hampshire also grows in the southern muskegs.

The Appalachian Mountains have also served as a pharmacopeia for the world—sassafras tea as treatment for bronchitis, ginseng root for its reputed aphrodisiac qualities, and wild ginger for relief from stomach problems. Oil of rhododendron helped ease the pain of rheumatic joints, and the bark of hemlock soothed burns and cuts. The tradition of collecting wild herbs, for medicines and for food, is still strong among some mountaineers. For food, poke sallet, dandelion greens, and ramps are fresh and welcome in early spring, when winter stores of dried and preserved foods have dwindled. The mountains also provide a host of fruits and nuts—pawpaws and persimmons, blackberries and huckleberries, hazelnuts and walnuts.

So the Appalachian Mountains have always been a wild garden of earthly delights, known to generations of mountain people and botanists. It is indeed, as the gravestone etching says, a "pleasant thing" to stand in this garden.

White-fringed phacelia

(facing page) by Pat O'Hara

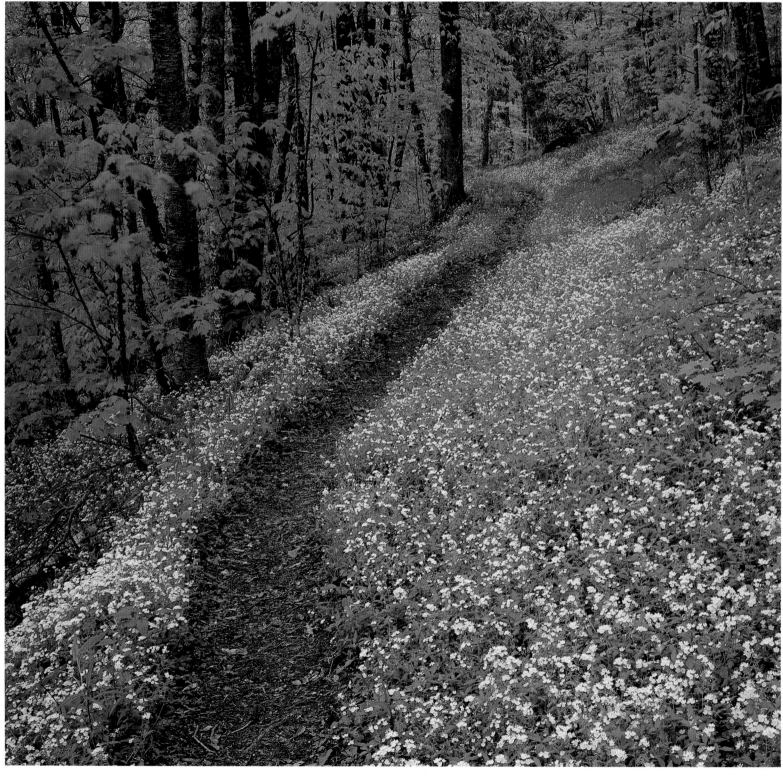

6 2

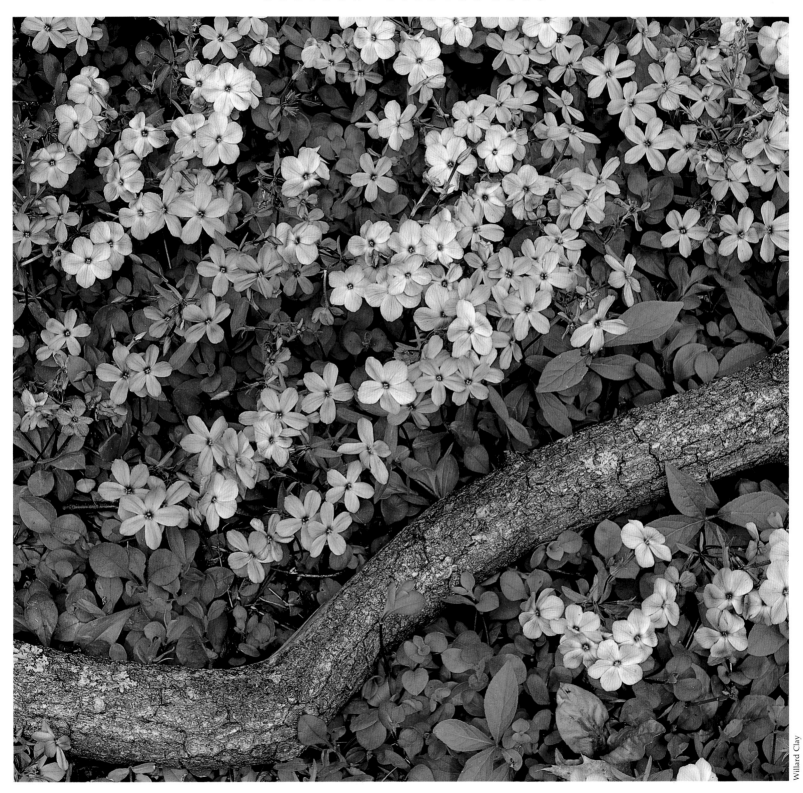

Willard Clay

W I L D B L U E P H L O X

Phlox spp.

The sixty-odd species of *Phlox* are all native to North America. Linnaeus named them, in direct translation of the Greek word for flame, in reference to the tall stalks of showy flowers.

Their colors, growth habits, and varieties render this a troublesome group to identify by species. The flowers are purple, to blue, to pink, to white; they may creep along the ground or stand erect up to three feet high.

Wild sweet William is a well-known native phlox of fields and woods. Creeping phlox, perennial phlox, and mountain phlox are among other wild species. Many varieties of phlox and their relatives, the moss pinks, are widely cultivated in gardens, and some have escaped into the wild.

The great American botanist, John Bartram, father of William, sent moss pinks to England in 1741. One English author declared that the day of their introduction should be celebrated as "a horticultural festival."

For most in the *Phlox* genus, butterflies and moths commonly carry on the job of pollination.

The family is known by the three-branched styles and three-chambered ovaries, as well as by the recognizable bell-shaped flowers that flare into five lobes.

6 4

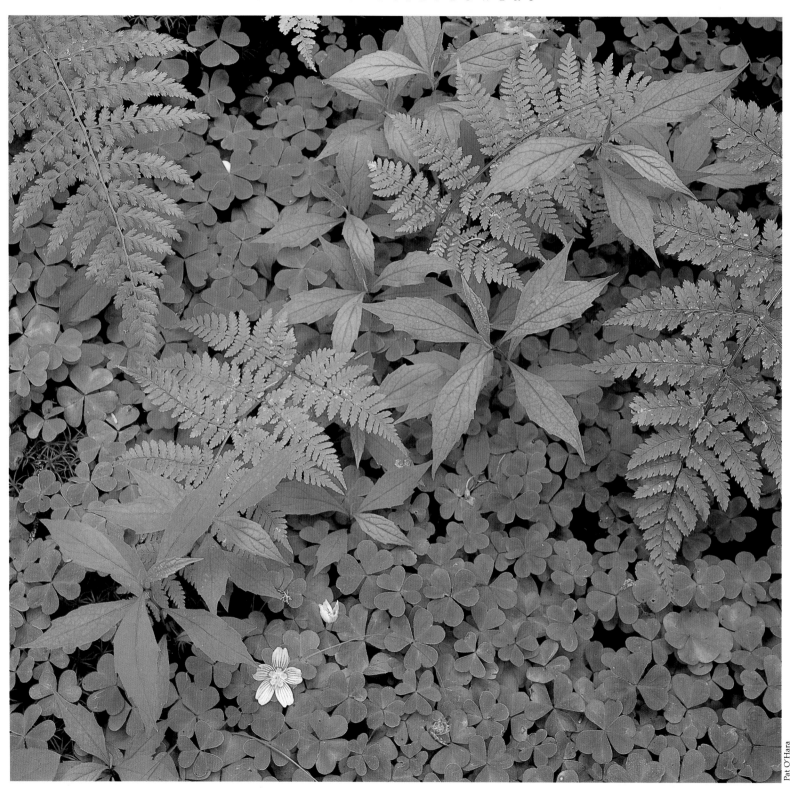

Pat O'Hara

W O O D S O R R E L

Oxalis montana

The winsome common wood sorrel might at first glance be mistaken for the spring beauty, were it not for the wood sorrel's distinct cloverlike leaves and later time of bloom. The leaves are a cool green, often much more obvious than the flower. Many consider this three-part leaf the shamrock of ancient Ireland.

One five-petaled flower grows on each stalk of this plant, with dark pink veins that act as "honey" or nectar guides for the butterflies and small bees that pollinate it. Formerly placed in the geranium family, it now belongs to one of its own, the wood sorrel family.

The North Carolina and Tennesee mountains mark its southern limit. In the Great Smokies common wood sorrel is especially abundant as a ground cover in the spruce-fir forests. The very name of the plant, wrote Mrs. William Starr Dana, brought "a vision of mossy nooks where the sunlight only comes on sufferance. . . . " It also grows in New England and into the Midwest, in cool moist woodlands.

We can take a hint from both the common and scientific names that this plant, though edible, should be consumed only in small quantities. *Oxalis* means "sour," and the word "sorrel" is a corruption of it. The stalks and leaves, high in vitamin C, may be eaten as greens, but the sour substance in them is poisonous in large amounts.

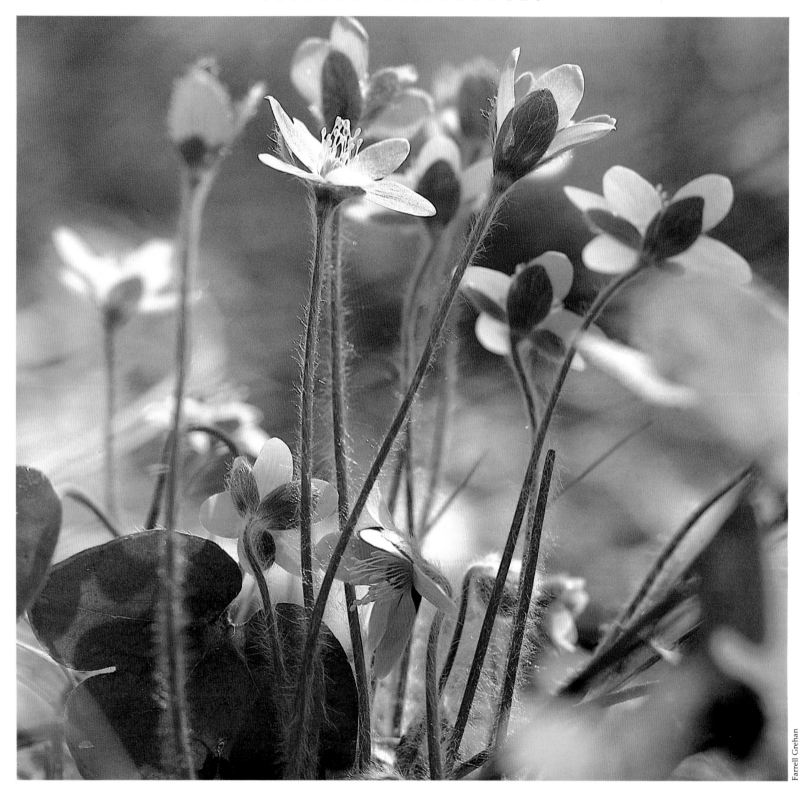

Farrell Grehan

H E P A T I C A

Hepatica spp.

ohn Burroughs, a preeminent nineteenth-century nature writer, said of the hepatica, "When at the maturity of its charms, it is certainly the gem of the woods."

There is no more welcome sign of waning winter than this cheering flower, poking through the duff as snow still lingers. The flowers appear amid winter-worn brown leaves, refugees from last year; fresh green leaves arise once the plant has flowered in spring.

The stems and buds are covered with fine hairs, good insulation for this firstling that blooms as early as March. In this way it resembles another early bloomer in the buttercup family, the pasqueflower of the prairies.

From pink, to lavender, to shades of blue, and even to white, hepatica exhibits a wide range of colors. The small "petals" are in fact sepals, usually from six to ten in number. Two similar species are distinguished on the basis of leaf shape—one round, one sharp.

Hepatica derives from the Greek word for liver. To the ancients the three-lobed, bronze-green leaves resembled lobes of liver. Under the doctrine of signatures, if a plant part resembled a part of the human body, it would cure ailments of that part. Hence hepatica could help an ailing liver. Liverwort and liverleaf are other names for this plant.

6 8

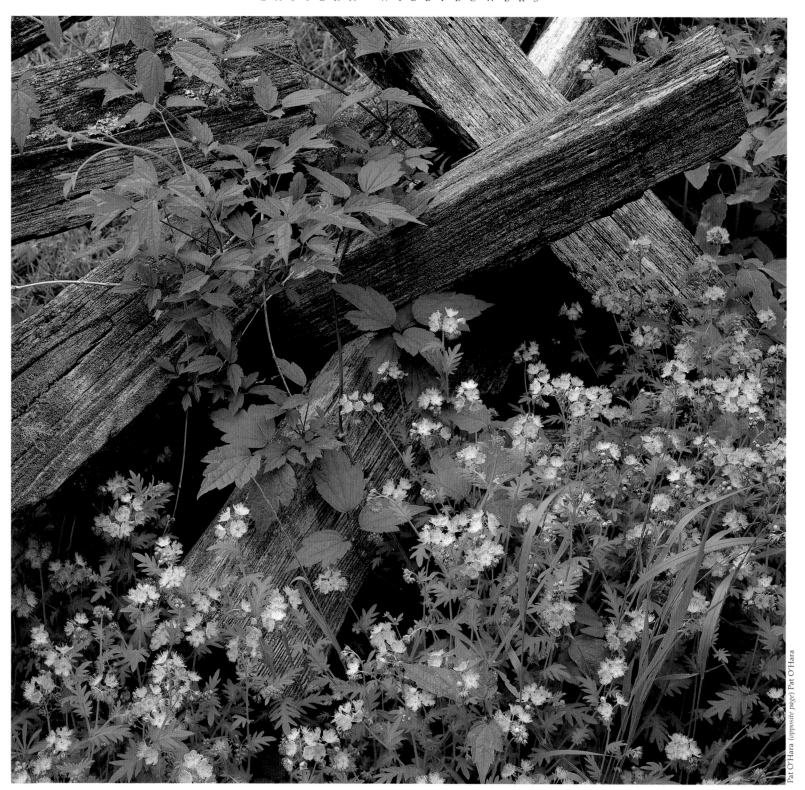

P H A C E L I A & F I R E P I N K

Phacelia spp. & *Silene virginica*

The French botanist André Michaux first found the phacelia (*facing page*) when he was botanizing in "les wilderness" of the eastern mountains of the United States from 1785 to 1796. These flowers are truly a spectacle in April and May in the Great Smoky Mountains.

They range from blue to purple and white, the purple phacelia reaching one to two feet high. The white-fringed phacelia is much shorter, only three to five inches. Extensive swaths of these flowers cover the ground like hailstones or, some say, patches of snow. The range of the white-fringed is fairly restricted, in upland woods from Virginia to Alabama.

Close-range details reveal how exquisite these flowers are. The five petals are united, with deep fringe on the tips—"fimbriate" in botanical jargon. Some are unfringed, such as the small-flowered and the loose-flowered (or purple) phacelia.

The Greek word *phakelos* is the root for *phacelia*, which means bundled; the flowers grow in a cluster at the top of a stalk.

Compared to its pastel sisters, fire pink (*this page*) in shocking crimson is a siren, lighting up roadsides in the mountains. The one- to two-foot-tall stems and the calyx are sticky, giving this flower the name catchfly. It belongs to the pink family, so named not for the color but because the petals are "pinked" or notched.

Farrell Grehan

JACK-IN-THE-PULPIT

Arisaema triphyllum

The "pulpit" from which Jack preaches is botanically known as a spathe. The inner fleshy spike that is "Jack" is technically a spadix, and at Jack's feet sit the tiny flowers, either all male or all female.

One fascinating aspect of this unusual plant is that Jack-in-the-pulpit could by all rights also be a Jill-in-the-pulpit. During its first year, the plant is usually male, and by the second year, female. And depending upon the environment in which it grows, the sex of the plant can even be changed. In dry conditions, it will more likely be male. In richer, more fertile ground it can be "made" to be female. This sex-change ability seems to be a strategy to assure survival, for even in poor conditions the male can still produce pollen, thus helping to make offspring.

The root, or corm, is edible and has given this plant another common name, Indian turnip. Harvested in summer or fall, and after prolonged drying and cooking, the corm loses its acrid calcium oxalate crystals. Those gluttonous with the "turnip" have paid the price of a burning tongue.

Indeed, the wild arums take their name from the Arabian word for fire, and many in the family, like skunk cabbage, exhibit the bitterness found in Jack-in-the-pulpit root.

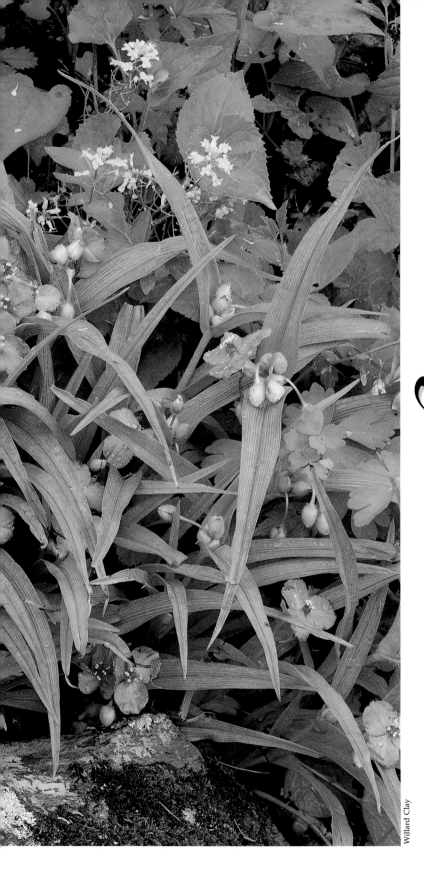

Willard Clay

S P I D E R W O R T

Tradescantia spp.

Spiderwort's six hairy yellow stamens tipped with yellow anthers look like French knots embroidered on the three petals. The flowers open only for a morning, and by afternoon the petals have turned to soft mush.

The hairs on spiderwort stamens are ideal to observe through a microscope, for they permit a closeup look at cytoplasm and cell nuclei in action.

Several species of spiderworts grow in the East, with pale blue to violet blooms. Their common name stems from the arrangement of the long pointed leaves, which to some imaginative souls resemble a crouching spider. The "wort" appended to the name hearkens back to the old English word for plant.

The family includes spiderworts and the dayflowers, which are similar to spiderworts except that two petals are large and one is small. The Latin name for the family and the dayflower genus comes from three Dutch brothers named Commelin. Two became botanists, while the third had no real achievements in the eyes of science. With a touch of humor perhaps appreciated best by Linnaeus, who named the family, the two large petals of the dayflower represent the two Commelins who did well; the third, less significant petal the one who died without a measure of fame.

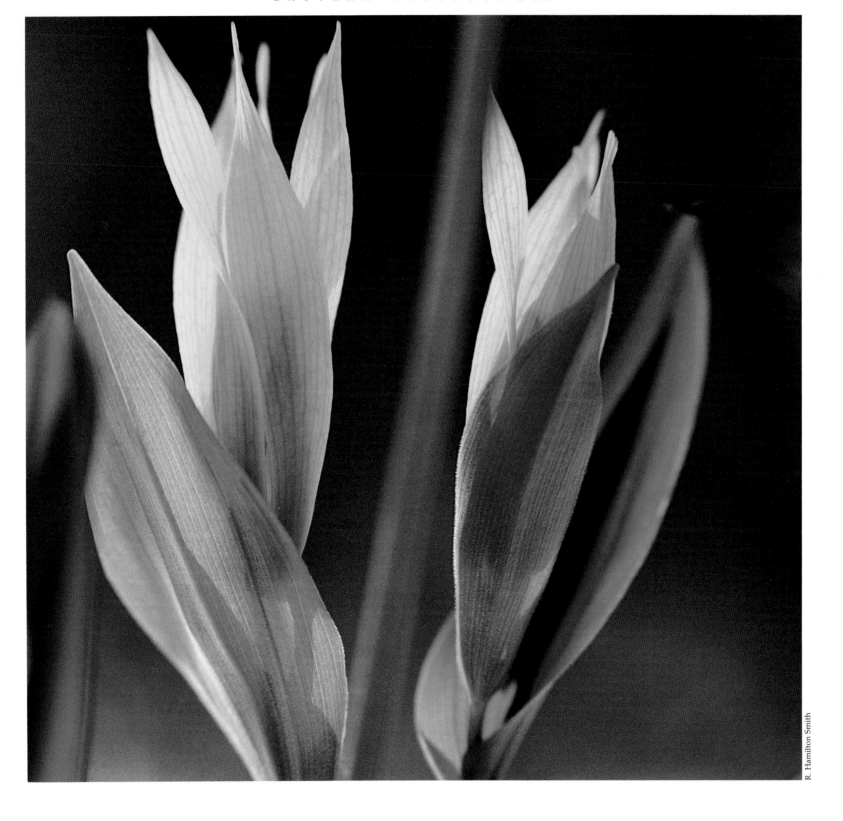

BELLWORT

Uvularia spp.

Bellworts are captivating woodland lilies, with one or two pale or lemon yellow flowers drooping from an angled stem. The three sepals, three petals, and six stamens reveal its family ties.

One bellwort species is called wild oats or merrybells. Another species, the mountain bellwort, is found both in the Appalachian Mountains and among the pine barrens of the coastal plain. Some botanists surmise that seeds of some plants were carried onto the plain by streams pouring from the mountains, possibly explaining this species' distribution. Compared to the inch-long flowers of these two, the large-flowered bellwort bears blossoms up to two inches long.

The plants were at one time used to treat throat problems. This connection to the uvula, the fleshy lobe that hangs from the soft palate, was made by those who followed the doctrine of signatures. In the case of bellwort, they saw similarity between the drooping flower and the uvula, which also explains the name of the genus, *Uvularia*. In addition, bellwort could ease skin inflammation and swellings from wounds.

Parts of the plant were good as food also. With the leafy portions removed and the young shoots boiled for ten minutes, bellwort makes a suitable asparagus substitute.

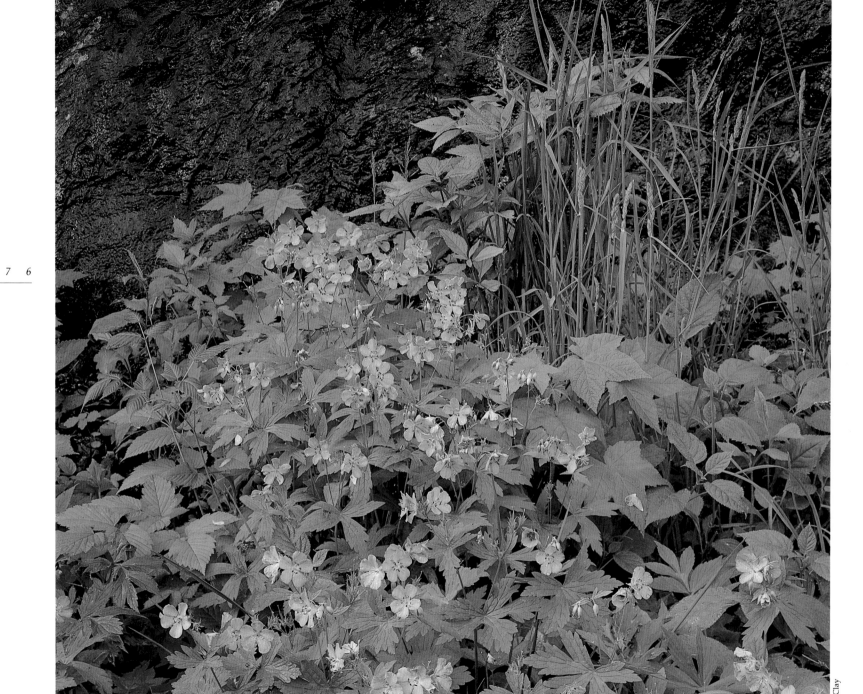

Willard Clay

WILD GERANIUM

Geranium maculatum

D ressed in fetching purple and pink, wild geraniums grace woods and meadows from Maine to Georgia. These common flowers of spring and early summer grow in loose clusters above large, deeply lobed leaves shaped like the palm of a hand.

Another name for geraniums is cranesbill, for the interesting seedpod they develop after the bloom is gone. The style forms a slender, pointed cone about an inch long, encircled at the base by what is left of the flower. It looks perhaps more like a rocket on a launching pad than the bill of a crane, but someone saw the bill distinctly, for the name *Geranium* comes from the Greek word for crane.

The flower bears five sepals, five petals, and ten stamens arranged in two circles of five each. The mature ovary separates into five parts, each of which holds a seed. The dry capsule splits and curls back, launching the seeds some distance from the plant. Though the flowers appear frail, this perennial sprouts from stout underground rhizomes each year.

The plant's astringent properties have been known for some time, with preparations of the root being used to stop bleeding, heal canker sores, and treat dysentery.

The wild geranium bears little resemblance to the popular window-box flower that we buy at the nursery. That plant, originally from Africa, is placed in a different genus.

Willard Clay (*opposite page*) Willard Clay

LADY'S SLIPPER & TRILLIUM

Cypripedium spp. & *Trillium luteum*

Some lady's slippers are found in dry pine forests, but others, like the yellow (*facing page*), find swamps and bogs and rich woods more to their liking.

Yellow lady's slipper is a fragrant orchid, flowering from late April into June. Though not common, where they do grow they sometimes form spectacular congregations. Both a large and small yellow species generally are recognized, but several varieties also occur.

An intricate association exists between the seeds of lady's slipper and a fungus necessary for the seeds to develop. But even when the fungus is present, the flower does not bloom for a number of years.

If *Lilium* becomes lilies, why not trillies for *Trillium*, asks botanist Harold William Rickett. One never knows; perhaps someday this will catch on as another common name for the yellow trillium (*this page*), already known by several colorful names. We have toadshade and wake-robin for two.

Naturalist John Burroughs expressed a philosophical attachment to the wake-robin: He wrote, "With me this flower is associated not merely with the awakening of the robin, for he has been awake some weeks, but with universal awakening and rehabilitation of nature."

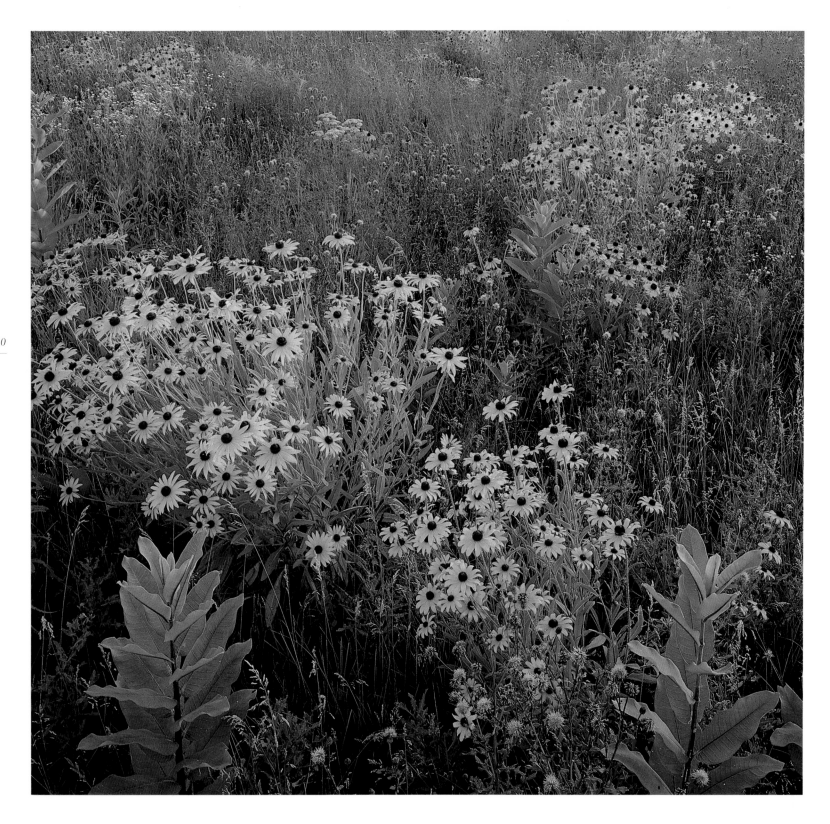

T he Middle West was land before it was people, a broad inland ground. To the south, alluvial; to the north glacial; to the east forest; to the west dry and barren of trees."

Author Richard Rhodes, a native of the Heartland, captured in these words much of the essence of the Midwest as the heart—the center—of the country. His "broad inland ground" is indeed the center, in more ways than one. In Kansas lie the geographic and geodetic centers of the forty-eight continental states. The geographic center is that point at which the area would theoretically balance, if all parts were uniform. The geodetic center, well-known to surveyors, is at a place called Meade's Ranch, the official station from which latitude and longitude are calculated in the United States. The central United States is where two major plant groups, trees and grasses, play a tug-of-war, and where polar and subtropical air masses convene, a circumstance that results in an amazing range of unmitigated weather.

But more than mathematically or physically, for many people the Middle West is emotionally the center of the country too. A place of small towns and farms, cornfields and wheatfields riding in waves on extremely rich black topsoil—some of the best soil in the world. Of weathered barns with "Chew Mail Pouch Tobacco" painted on their roofs, roadsides lined with Burma Shave signs, childhood nights filled with fireflies, summer baseball games, and church potlucks. It is a place of smells, mostly decaying manure, and of sounds, always the mournful trains passing by solitary grain elevators, softened by the distance and the night.

Field of prairie flowers

(facing page) by Willard Clay,

Dutchman's breeches (far right)

by R. Hamilton Smith

The terms applied to the land—the stable craton, the platform, the shield—also describe the character of the people who settled the area. Disciplined Germans and Scandinavians, industrious New Englanders, and tough southern highlanders. The picture the Heartland presents, as one writer said so well, is of "men and women who take their living from the soil."

The Heartland, as defined here, is a huge area, from the Canadian border, down and across the Mississippi River, fading onto the Plains and the beginning of the West. This is a generous definition of the Midwest, including Ohio, Indiana, Illinois, and Iowa; Minnesota, Michigan, and Wisconsin; western Kentucky and west Tennessee; Missouri and Arkansas and some of northeast Texas. Such a large swath of land necessarily offers habitats from hardwood forests and conifer woods to tallgrass prairie and river bottoms.

So there is variety in the Midwest, especially if taken from north to south. We will start in the far north, the land of the conifers—spruce, fir, and pine—and of the red-capped, red-sashed French Canadian voyageurs, who celebrated in lusty legend and song their famed canoe expeditions on the thousands of lakes and waterways. This is known among botanists as the boreal forest, for Boreas, god of the north wind, whose cool breath blows over land. Sigurd Olson, poet laureate of the north woods, describes it as the land where the stars are so close you seem able to reach out and touch them.

Some of the wildest and emptiest land in the eastern United States rests undisturbed in far northern Minnesota and northern Michigan and Wisconsin. As in New England, glaciers advanced over the land, at least four times over the Heartland, reaching as far south as St. Louis and Cincinnati. After the last one receded, some 12,000 years ago, the forests returned, first birch and aspen (known better in this part of the country as beaverwood or popple), and then the conifers. The glaciers pockmarked the north country with holes that filled with water, earning the region the name "land of a thousand lakes." A quick glance at the maze of blue spots on a map (and at Minnesota's license plate) confirms it, without exaggeration, as the land of *ten* thousand lakes.

Granite cliffs and rocky headlands meet the water's edge, as do the brooding forests. This is formidable country to find your way around in, with thousands of miles of trees and water with precious few notable landmarks, at least to the inexperienced eye.

And as the voyageurs and Indians long knew, the best way to get around in the north country is by paddling the functional and pleasurable canoe, or, when the waterways are solidly frozen, by foot. The best time to travel by boat is between May 1 and October 1, after spring breakup but before autumn freeze. At places the roar of rapids means portage, along the same trails blazed by Indians and voyageurs. Sinking to your knees in leech-infested black muck with an 80-pound canoe on your shoulders is all part of the north woods experience.

Spring comes a bit later to the north country than to the southerly parts of the Heartland but is worth waiting for. The Chippewas of the Lake Superior region knew May as the Flower Moon, in recognition of the early spring wildflowers that graced the land. Blue mayflowers, marsh marigold, and dogwood appear as the northern pike are spawning. By the water's edge are bluebell and cinquefoil, apparently liking life on the rocks, while wintergreen, wood anemone, and twinflower prefer the floor of pine forests. The paired flowers of twinflower, the "twin sisters" of the north woods, were one of Carolus Linnaeus's favorites. His affection for them is recorded in the plant's scientific name, *Linnaea*. Large-leaf aster and wild sarsaparilla are abundant, and fireweed blazes in the clearings created by forest fires and logging. Sandy lakeshores are covered with silverweed, and the peat bogs with a shrub called leatherleaf, along with other low-growing arctic and subarctic plants. Also among the extensive bogs and muskegs lurk the insectivorous pitcher plants and sundews.

Lake Superior, as the name suggests, dominates much of the north country. The largest freshwater lake in the world, Superior poses as the top step of the staircase of the five Great Lakes, which together represent a third of the world's fresh water area. The silvery waters of Lake Superior extend to the horizon like the ocean, and to depths of more than 1,300 feet. It forms the northern border of Michigan's Upper Peninsula, the country of Hiawatha and Lake Gitche-Gumee, "the shining Big-Sea-Water."

Superior also defines the northern border of Wisconsin,

which holds within its state boundaries a wildflower treasury. On the Door Peninsula is a place known as the Orchid Ridges, where in the boggy troughs between low ridges at least twenty-four different species of orchids have been identified. Protected there in a wildflower sanctuary are the long-bracted, round-leaved, purple-fringed, and blunt-leaved, ram's-head and adder's mouth, twayblade, and calypso.

Edwin Way Teale gives a lovely description of one of the Door Peninsula orchids, the showy lady's slipper, known also by the charming common name, whippoorwill's shoes. There were "half a hundred of them. . . . Each waxy-white and crimson-tinted flower, delicate as a bubble, hung pendant on its stalk." Wisconsin's premier conservationist, Aldo Leopold, noted a remarkable ecological association between rabbits and lady's slippers. From 1932 to 1935 rabbits were abundant in that part of Wisconsin. They browsed the bog birches, opening the area to more sunlight. The lady's slippers grew. But by 1936 and 1937 the rabbits were on a down cycle, which meant more birches and fewer lady's slippers.

From the wild land of the north, we go to another region of the Heartland, that part perhaps most traditionally associated with the Midwest. This is the great breadbasket for the world, the corn and wheat country of Iowa, Indiana, Illinois, eastern Kansas, Nebraska, and Oklahoma. Included too are the northern half of Missouri, the eastern Dakotas, and western Minnesota. In 1840 this was the American frontier, and in 1840 it was unbroken by the plow. Intensive modern agriculture has erased almost all of what the land was then. It was solid prairie when the settlers arrived, extending six hundred miles in breadth and running for more than a thousand miles toward the Gulf of Mexico. But, wrote Leopold, "No living man will see again the long-grass prairie, where a sea of prairie flowers lapped at the stirrups of the pioneer."

At a dollar and a quarter an acre, the first settlers, from the piedmont of Virginia and the Carolinas, claimed the land and paid in gold or in land warrants. As author John Madson has written, "In one lifetime the great tallgrass reaches of middle America had been opened, broken, and inked into deeds."

Those early settlers left their impressions of the prairie, likening it often to the sea. Emerging from the "gloomy for-est" and "impenetrable foliage" of the eastern forests, these newcomers spoke of the prairie's light and gaiety. Wrote one: "The attraction of the prairie consists of its extent, its carpet of verdure and flowers, its undulating surface, its groves, and the fringe of timber." Others, not so enchanted, spoke only of endless monotony and unendurable loneliness.

They first noticed spots of prairie in western Ohio and Kentucky, increasing in size in Indiana, a peninsula of prairie extending into deciduous woodlands. About twenty miles west of the Wabash River at the eastern edge of Illinois' Grand Prairie they stepped irrevocably into a land, writes Madson, "that blazed with light and space." At their backs, he notes, were the trees and flowers of the "Old States," and before them were prairie coneflowers, compass-plants, and a sea of grass.

There were trees on the prairie, basswood replacing beech, green ash taking the place of elms, and cottonwoods instead of sycamores. But as the frontierspeople pushed west, they saw the trees holding on to the streams and riverbanks, unable to compete with the grasses.

What seems to explain the prairie's existence is a fairly simple climatic fact—evaporation exceeds precipitation. This wasn't always an obvious point to botanists and ecologists, who have pondered the grassland phenomenon for a long time. Edgar Transeau finally solved the equation by carefully plotting ratios of evaporation and precipitation. Where the ratio of rainfall to evaporation is less than one to one, grassland, scrub, or desert are found. Prior to his work, the theories about possible prairie makers were legion—poor soil, wildfire, grazing bison, blowing wind. Though these factors may contribute to maintaining prairie, they are not considered the parents of prairie.

The eastern prairie was mostly tallgrass, grading into mixed grass, and shortgrass out on the Great Plains. Boggling to imagine now, some 150 kinds of tallgrass existed, reaching proverbial heights of six feet. The presence of these grasses—slough grass or ripgut, switch grass, Canada wild rye, Indian grass, needle grass, porcupine grass, and always big and little bluestem—indicated healthy prairie. The grasses lay at the heart of plains life. Their roots formed the sod that accounted for the extravagant fertility of the soil, and in the absence of

any sizable timber, the sod made the roofs and walls of settlers' homes.

Where native prairie remains, wildflowers form whole gardens from early spring to late fall—the smaller ones in spring, like the pasqueflower, followed by their taller counterparts in autumn, especially the quintessential prairie blossom, the common sunflower. In April, as big bluestem appears, on come the Indian paintbrush, yellow star-grass, and prairie pinks. By early May, writes John Madson, when the bird's-foot violets arrive, a sunny prairie slope looks like the sky fell in on it. Daisies, larkspur, butterfly milkweed, and purple coneflower signal summer; Madson suggests that "if you can make but one annual visit to a patch of tallgrass prairie, the Fourth of July is a good time to do it." In late summer and early fall, gayfeather, goldenrod, and gentians join the hosts of bright sunflowers.

The great nineteenth-century botanist Thomas Nuttall wrote of the prairie he found, not in July, but in January of 1819. After a three-month journey down the Ohio and Mississippi rivers to the Arkansas, when nothing had appeared to him "but one vast trackless wilderness of trees," he came upon Arkansas's Grand Prairie. Already blooming were false garlic, spring beauty, and rattlesnake master. Just beyond present-day Little Rock, "romantic" hills presented themselves; from the top of one high point Nuttall gazed south to the Ouachita Mountains and north and west to the plateau of the Ozarks.

He remarked on one plant that "forbode the vicinity of the Mexican desert." Here in the Ozarks was a prickly pear cactus, growing amid plants of the east, north, and south. These old hills—or mountains, depending upon your point of view—extend as an elevated, dissected plateau from northwest Arkansas into southern Missouri. The Ozarks represent one of the lesser tamed regions in the middle of America, and they are the only really high area, besides the Ouachitas, between the Appalachians and the Rocky Mountains.

The plants of the Ozarks have come from other places and other times. The plateau is isolated on three sides by major rivers—the Missouri, the Mississippi, and the Arkansas—and on the west by prairie, an isolation that results in unique plant and animal inhabitants. In the Ozarks, too, is the confluence of the four major environments of the eastern United States. This is as far west as the eastern deciduous woods extend and about as far south as the ice-age glaciers reached. In Missouri's boot heel reposes the rich alluvium of the Mississippi River, and to the west, as Nuttall discovered, stretches sunlit prairie land.

So in only a few square miles you might find species of the eastern forests, north woods, humid delta, and dry grasslands, offering a veritable "botanical museum without walls." The prickly pear that caught Nuttall's eye indeed forbodes desert and is only one example of the plant life that the Ozarks have borrowed from neighboring regions. We find also harebell, reminiscent of the north; bloodroot, better known in Appalachia; and water tupelo, common to the southern swamps and bayous.

These mystical mountains hold all kinds of secrets (besides the proverbial moonshiner's still). Caves hide deep in the ultimate darkness inside the earth; lovely rivers meander through the countryside, fed by clear, intensely blue springs. The same porous limestone that contains the caves and bears the springs also supports a wide variety of wildflowers—fragrant rose verbena, purple phlox, spiderwort, false indigo, wild hyacinth, milkweed, glade lily, and lovely flowering trees and shrubs like dogwood and wild azalea.

The nation's midsection may warrant a slowing down, a closer look. The variety of this "broad inland ground" is not always immediately apparent, but it is there, beside a road, along a railroad track or fencerow, up a valley, in a bog, or by a spring-fed stream.

Lupines (facing page)

by R. Hamilton Smith

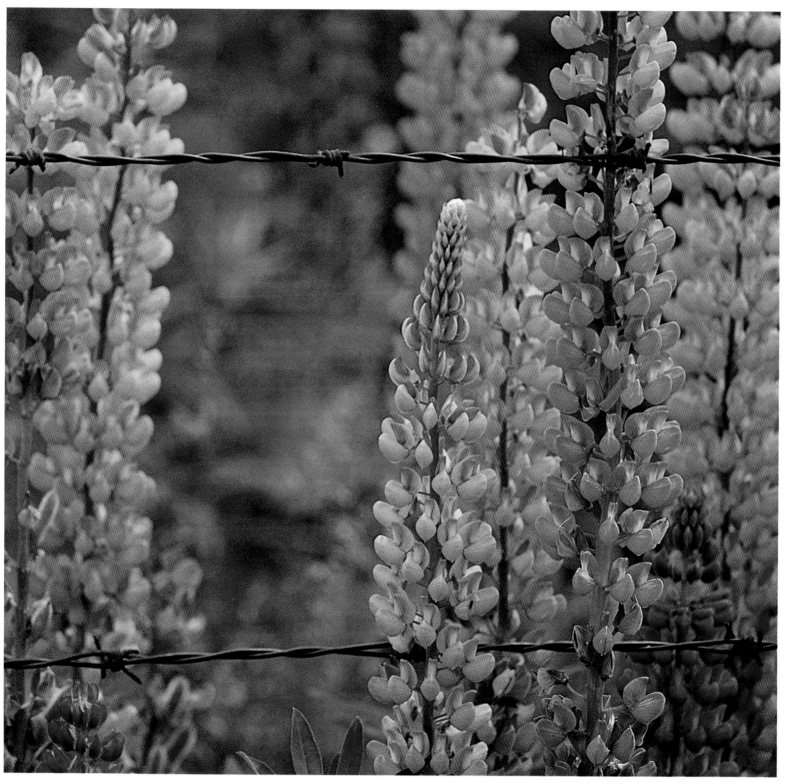

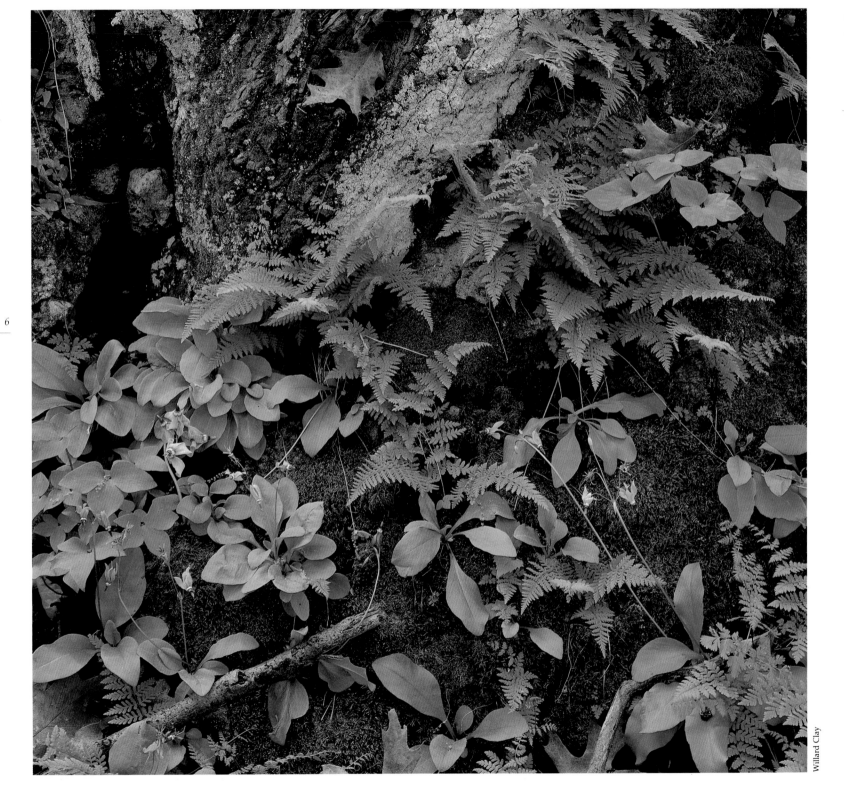

SHOOTING STAR

Dodecatheon spp.

*A*h, the shooting stars. We may read of their basal, lanceolate leaves, know that the stem grows six to twenty inches tall, and discover that each of the five petals has a stamen opposite it. But beyond their technical description, shooting stars are just breathtakingly beautiful.

The pink petals point up to the heavens, and the yellow ring at the base of the flowers leads toward earth. They grace open woods, meadows, and prairies and were once far more abundant. In the vernacular of plain-spoken early settlers, they were called prairie pointers.

Dodecatheon meadia, named for English physician and botanical patron Richard Mead, is a common species. A deeper crimson one, known by the lovely name of amethyst shooting star, grows along the bluffs of heartland rivers.

Rather particular wildflowers, shooting stars need moisture and good weather to bloom; they either delay or completely avoid flowering when conditions do not fit their needs.

Claude Barr writes in his *Jewels of the Plains* that he has spent many years "jaunting among the 'stars' in search of finer form and outstanding colors; the finds, and memories spent in search, are equally guarded treasures."

Though they appear delicate, these lovelies are well adapted to retreat underground when drought or fire descend upon them, springing back to life when conditions have improved.

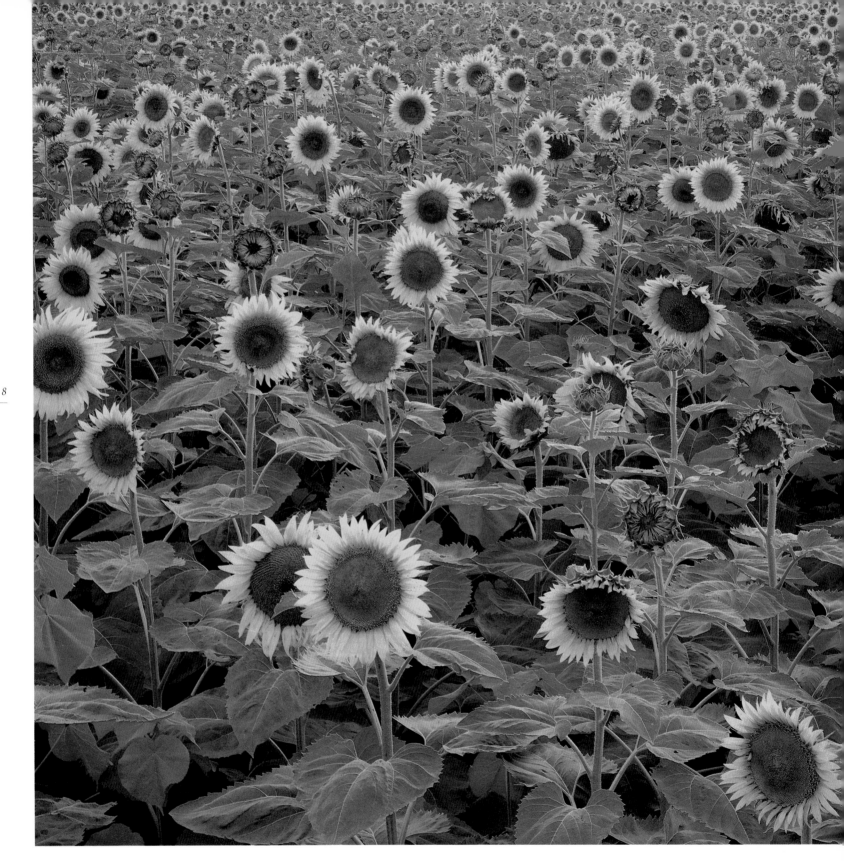

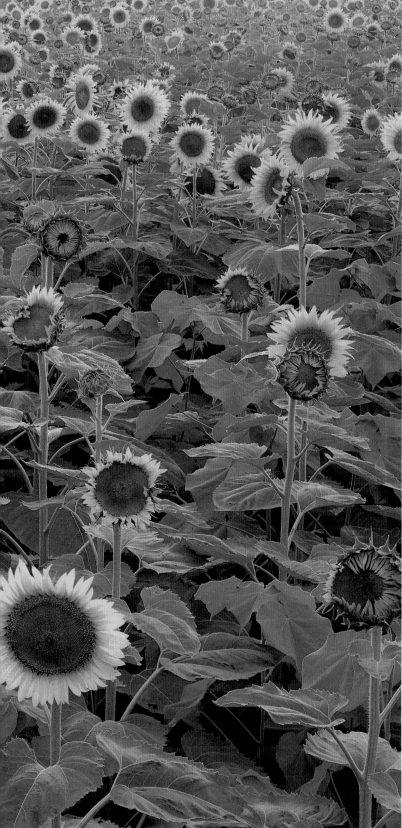

S U N F L O W E R

Helianthus spp.

Sunflowers are nothing but big overgrown daisies. If you study them, you will see they are built like all the others in this huge flower family—ray flowers encircle a disk, also made up of tiny flowers, which on the sunflower are "packed together like the honiecombes of Bees," wrote herbalist John Gerard.

Helianthus takes it name from the Greek word for sun (*helios*) and flower (*anthos*). The 150-odd species of annual and perennial sunflowers are almost all native to North America. We have the common, giant, swamp, stiff, ashy, and prairie sunflowers. In some species the flowers attain astonishing sizes: the largest sunflower ever measured was two and a half feet in diameter.

Sunflowers have served as pantry and general store for many, many years. White settlers found Indians cultivating them, munching the oil-rich seeds, making a yellow dye, and even treating snakebite with a poultice of the plant. The pioneers in turn learned to use the stalks for fiber and the leaves as a tobacco substitute.

The language of this late summer flower is "haughtiness," perhaps because of its tall stature and bold demeanor. That the heartland state of Kansas has elected this as the state flower is only fitting.

9 0

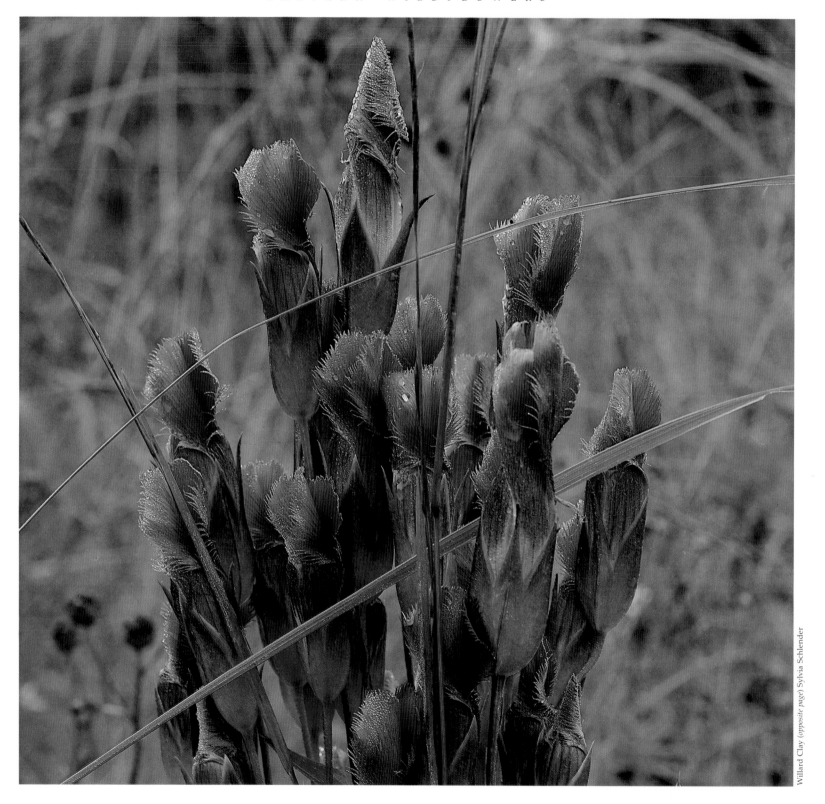

F R I N G E D G E N T I A N

Gentiana spp.

Good King Gentius, monarch of an ancient country on the Adriatic Sea, was the first, they say, to publicize the virtues of gentians as medicine. He found them a cathartic and a tonic. North American pioneers took him at his word and spiked their gin or brandy with a nip of gentian bitters, to stimulate the appetite and aid digestion.

The gorgeous gentians, blue as an Indian summer sky, are some of the last flowers to bloom in late summer and fall, when there is a chill in the night air. Emily Dickinson wrote of them: ''But just before the snows/There came a purple creature/That ravished all the hill.''

Look for gentians in moist woods and meadows and along streams. Fringed gentians, like the one on the facing page, stay closed until sunlight signals their unfolding. When the cupped flower opens, the fine fringes on the lobes of the petals are strikingly evident. These annuals distribute their many seeds widely, so flowers may turn up in a new place a year hence.

Other species, the bottle or closed gentians, never open. The flowers form tight clusters about the top of the stem. Thoreau called their color a ''transcendent blue.''

The gentians family is famed for handsome, richly colored flowers with four or five joined petals.

9 2

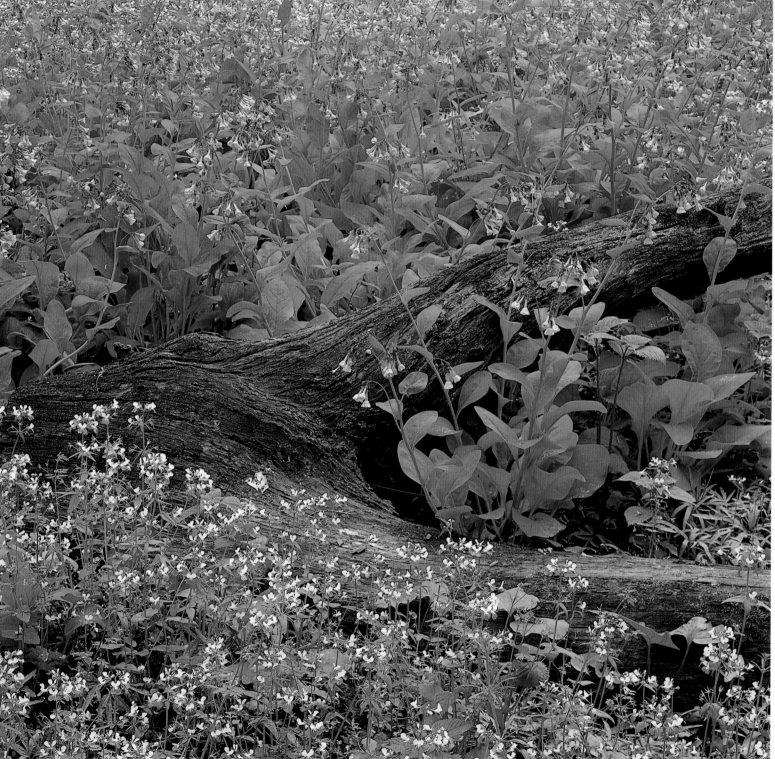

Willard Clay

VIRGINIA BLUEBELLS & BLUE-EYED MARYS

Mertensia spp. & *Collinsia* spp.

We can almost hear ringing from the clusters of delicately colored blue bells that hang from the stems. The blue flowers of Virginia bluebells start out as pink buds, and when fully open and growing en masse they put on a lovely show.

The petals join at the base to form a constricted tube. The blossoms, about an inch long, appear from March to June in river bottoms, wet woods, and sometimes meadows. They grow from a coiled bunch that unrolls as the flowers expand.

Virginia bluebells have earned several common names, one of which is lungwort, for their resemblance to a plant divinely inspired to cure lung diseases. Another is Virginia cowslip, though it is not related to the yellow cowslips of the primrose family that grow in Europe. Neither is it a true bluebell, belonging instead to the borage or forget-me-not family. The genus *Mertensia* takes its name from German botanist Franz Karl Mertens.

Tributes to them have been, shall we say, flowery. One English writer declared superlatively that the *Mertensias* surpassed all other North American flowers in beauty, and the Virginia bluebell was the fairest of them all.

From a distance, the blue and white flowers of blue-eyed Marys (*foreground*) look something like violets on a tall stem. But these are members of the snapdragon family, found in damp woods in spring.

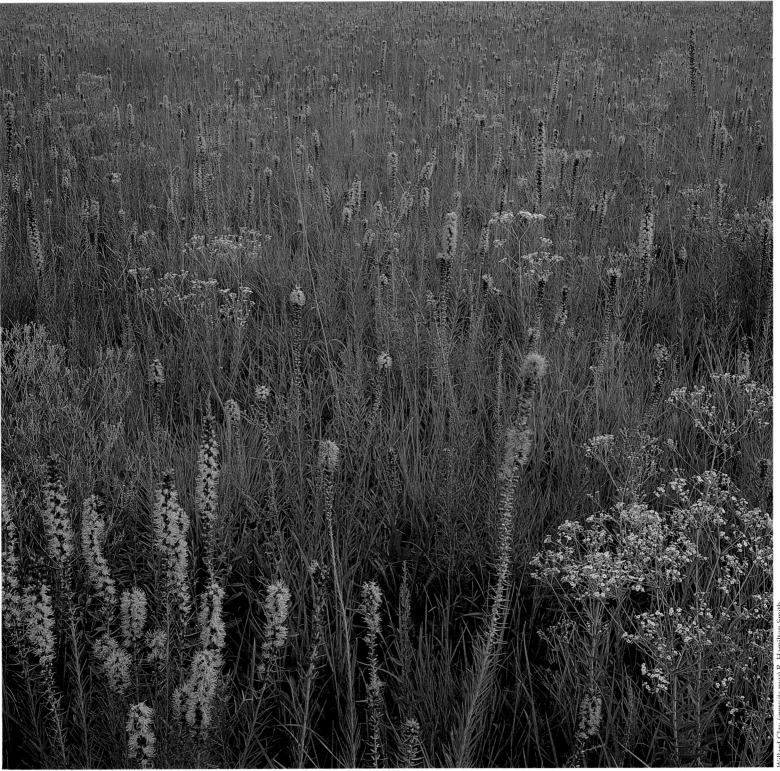

9 4

B L A Z I N G S T A R

Liatris spp.

From grasslike foliage arise the eye-catching rose-purple *Liatris* flowers, aptly named blazing star or gay feather. The flowers bloom from the top down on the spike.

Hardy *Liatris* likes dry land, and will appear in fields or along roads with abandon. Some forty species are found in the United States and Canada, not only in the grasslands but also from New England to the southern states.

Like so many in the composite family, identification of *Liatris* species is tricky. A hand lens, a botanical background, and good eyes are often the only recourse. Certain species are separated on the basis of the number of flowers in the flower heads, while in others the fruit is needed to provide proof positive.

Author John Madson is a *Liatris* lover. Despite their botanical perplexities, he says that "when the August prairie is lit with the blossoms of *Liatris*, such things as technical pedigrees lose their importance." They could, he thinks, win a popular vote as the favorite flower of the prairie.

Blazing star (*this page*) is visited by a monarch butterfly. Some flower-insect associations can be extremely exclusive—one species of butterfly, the blazing star skipper, feeds almost entirely on a certain species of *Liatris*.

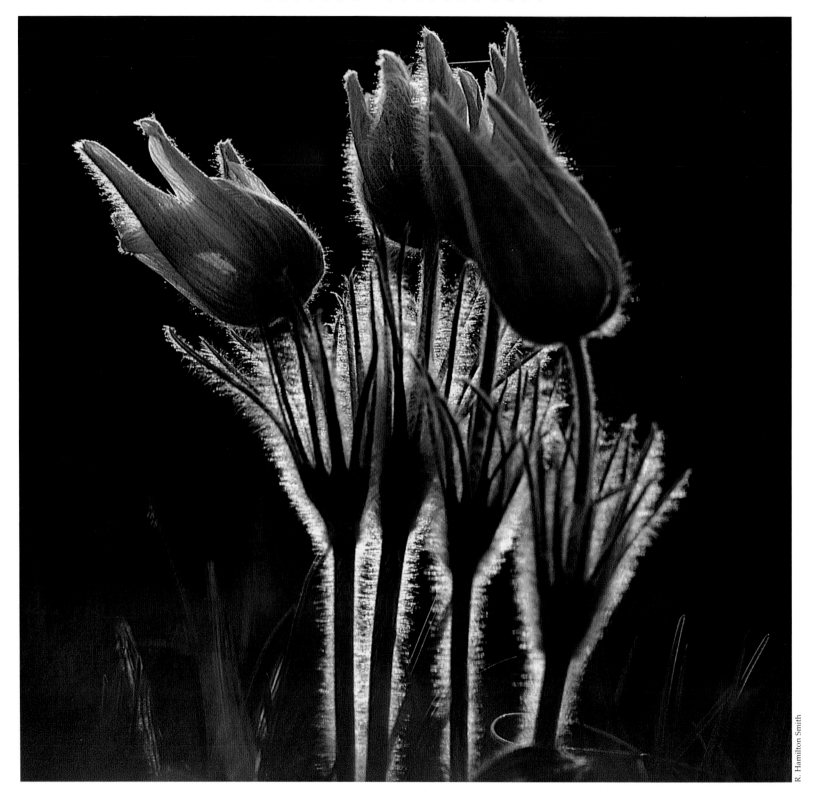

R. Hamilton Smith

PASQUEFLOWER

Anemone spp.

*P*asque is the Old French word for Easter and Passover, and in parts of Europe the anemone still is known as the Easter flower. In our prairie grasslands and on glacial ridges its soft blue flowers appear quite early, blooming in spring before the canopy of tall grasses covers the plant.

The five to seven "petals" are actually sepals, lending the flower a tulip or crocus appearance. In fact, old-timers call it crocus, while others may know the anemone as the gosling plant, for its covering of soft hairs.

"The whole plant," writes Harold William Rickett, "is silky with long hairs, the flower in early spring appearing to rise from a nest of silvery fur." This warm cloak is useful when leftover winter storms descend upon the prairie. At such times, the careful pasqueflower closes up shop and waits until the weather is favorable and insects are abuzz. Legend has it that the anemone is a fairy shelter that closes to protect its occupants. When the tinted cup opens, a fairy's playground of golden stamens is revealed.

The fat buds of these perennials appear on the ground in the fall, then in spring they ripen rapidly. After several days of flowering, the sepals fall, the stalks lengthen, and the new leaves come up. Botanists call this type of flower "prevernal," because blooms appear before spring officially arrives.

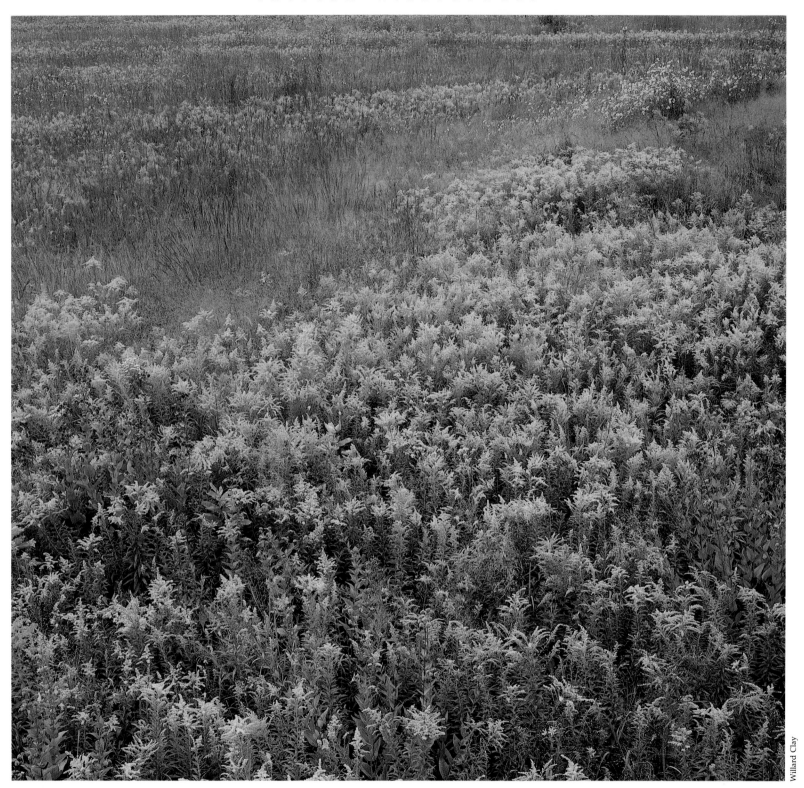

Willard Clay

GOLDENROD

Solidago spp.

R ods of gold are a fine way to think of these abundant flowers, which decorate meadows and roadsides all over the country with copious feathery plumes in late summer and autumn.

Though easy to identify as a group, there are so many species of goldenrod that a botanophil would find it well nigh impossible to separate them. As Mr. Rickett says, "The great genus *Solidago* cannot be recommended to the amateur naturalist for the easy identification of its species." And we must add this genus to its amazingly complex family, the composites. In the composites, the flower heads are in fact made up of two flower types—disks and rays—both of which are yellow in almost every species of goldenrod.

The genus name comes from the Latin *solido*, "to make whole or strengthen." It was known as the Plant that Consolidates, for its ability to stanch bleeding and heal wounds. The English herbalist Culpeper commended goldenrod to treat kidney stones and "to provoke urine in abundance. . . . It stayeth bleeding . . . It is a sovereign wound herb." And a decoction of the plant can "fasten teeth that are loose in the gums."

Goldenrod is unjustly accused as the culprit responsible for hay fever, when in truth wind-borne pollen of ragweed and others should be held accountable.

1 0 0

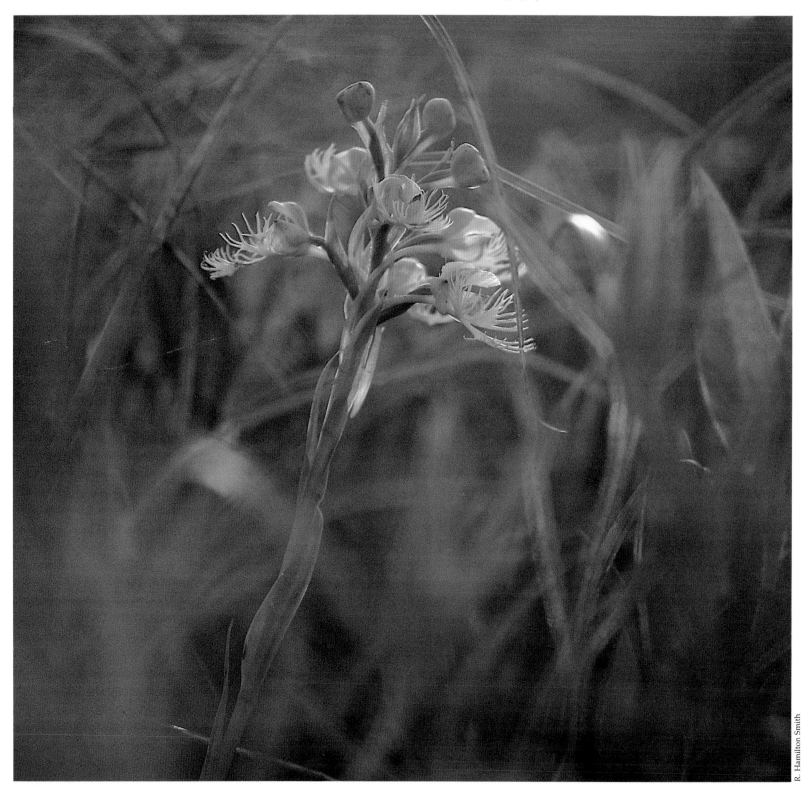

F R I N G E D O R C H I D

Habenaria spp.

An unexpected and pleasant surprise awaits those who poke around in the prairie grasslands long enough. A white-fringed orchid may appear, ghostlike, among the blades of green and silver.

This lovely, unassuming orchid sends out a fragrance at dusk that attracts the sphinx moth, its pollinator. The moths must work to get the nectar, which is buried in the flower's long hollow tube or spur. When the moths come up from feeding, their eyes and tongues are covered with sticky pollen masses, which they then carry to another flower to achieve cross-pollination.

Habenaria, relicts of a climate that was once much moister, prefer wetter places on the Midwest prairie. The genus name derives from the Latin word *habena* for rein, probably due to the fringed lip petals. The petals extend at their base into spurs, which on at least one species are about an inch long.

The spur—the tube formed by the extended lip petal—can be diagnostic for some species, though the fringed orchids' variations and propensity to hybridize make species identification difficult.

The usually small flowers of most *Habenaria* arrange themselves along the sides of a central stem. Though the white flowers of the prairie fringed orchid may be rather inconspicuous, other fringed orchids range from magenta and pink to orange and yellow.

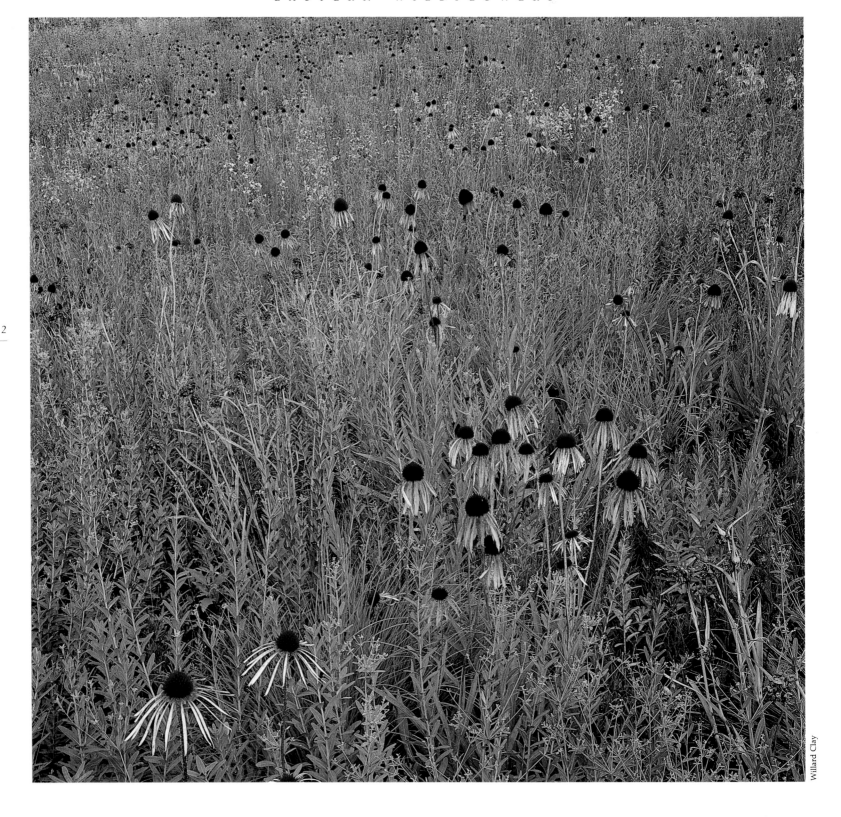

Willard Clay

PURPLE CONEFLOWER

Echinacea spp.

Just about any prairie flower with a dark center and longer outer "petals" wins the appellation "coneflower." They all belong to that great confusing conglomeration known as the composite family.

This coneflower is of the genus *Echinacea*, named for the central disk's pointed "chaff" that reminded someone, possibly Linnaeus, of a hedgehog. At least six species are recognized in this genus, growing mostly in the eastern plains.

Single flowers perch atop slender rough stems. The outer rays are usually pale purple, sometimes verging on white. The center dome is dark purple or brown. This flower of the summer prairie blooms in May and June in fields and woods, and shows a propensity for limestone soils. Like many prairie plants, purple coneflower grows an impressive root system—its taproot can reach eight feet into the ground.

John Madson has observed that even after the purple coneflower has shed the "petals," its straight or twisted stem, slightly swollen at the seed head, is distinct.

Its other common name is black Sampson, probably for the thick black root. Plains Indians applied pieces of the root to an aching tooth, and juice from the root was used to soothe burns and heal wounds. The active ingredient is echinacea, a drug recognized in the National Formulary until 1950, used to treat blood poisoning, typhoid fever, and syphilis.

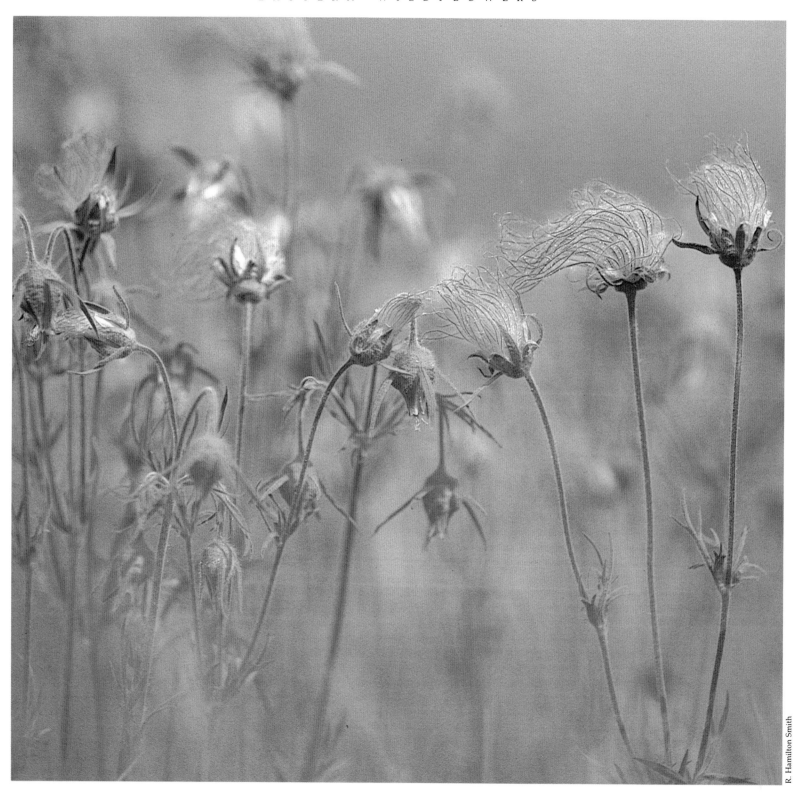

R. Hamilton Smith

PRAIRIE SMOKE

Geum spp.

The downy fruits of prairie smoke look more like an exotic sea creature—a medusa—than a wildflower. The plumed tails of the pinkish-gray fruits arise from rose-tinted flowers, often growing three together.

This is an early bloomer on the prairies, found from late April through July and August. Like pasqueflower, the plant guards against fickle weather with insulating hairs. You may find, upon consulting a field guide, that the pasqueflower is often listed as prairie smoke too.

Old-man's whiskers, torch flower, and purple avens are other descriptive and imaginative common names this flower has earned. Most flowers in the genus *Geum* have commonly been called avens, flowers ranging from low altitudes to above treeline.

The dark green leaves, also downy, sprout from a thick rhizome. Stems may reach a foot in height, branching off to bear the three flowers whose petals rarely open to full flower. A close look at prairie smoke shows characteristics that place it in the rose family—five petals and five calyx lobes and many stamens.

Prairie smoke grows mainly in the northern heartland area—the Great Lakes states, Minnesota, Iowa, North Dakota, and south into Nebraska.

Indians brewed a tea from the roots of prairie smoke.

elect Bibliography

[Author's note: This is a bibliography of selected sources and is not in any way exhaustive. To cover an area as large as the eastern United States meant consulting numerous individual books both by state and by region, many of which were extremely helpful with information about specific flowers. Also, the old Works Progress Administration guides to the various states were useful background sources.]

Borland, Hal. *A Countryman's Flowers*. Alfred A. Knopf, New York. 1981.

Brooks, Maurice. *The Appalachians*. Houghton Mifflin, Boston. 1965.

Buckles, Mary Parker. *The Flowers Around Us*. University of Missouri Press, Columbia. 1985.

Carr, Archie and the Editors of Time-Life Books. *The Everglades*. Time-Life Books, New York. 1973.

Dana, Mrs. William Starr. *How To Know the Wild Flowers*. Dover Publications, New York. Revised edition by Clarence J. Hylander, 1963.

Doolittle, Jerome and the Editors of Time-Life Books. *The Southern Appalachians*. Time-Life Books, New York. 1975.

Durant, Mary. *Who Named the Daisy? Who Named the Rose?* Dodd, Mead, New York. 1976.

Farb, Peter. *Face of North America*. Harper & Row, New York. 1963.

Feibleman, Peter S. and the Editors of Time-Life Books. *The Bayous*. Time-Life Books, New York. 1973.

Hay, John and Peter Farb. *The Atlantic Shore*. Harper & Row, New York. 1966.

Line, Les and Walter Henricks Hodge. *The Audubon Society Book of Wildflowers*. Harry N. Abrams, New York. 1978.

McCarthy, Joe. *New England*. Time-Life Books, New York. 1967.

Madson, John. *Where the Sky Began*. Sierra Club Books, San Francisco. 1982.

Martin, Laura C. *Wildflower Folklore*. The Globe Pequot Press, Chester, Connecticut. 1984.

Meeuse, B. J. D. *The Story of Pollination*. The Ronald Press, New York. 1961.

Mohlenbrock, Robert H. *Where Have All the Wildflowers Gone?* Macmillan, New York. 1983.

Niering, William A. *The Audubon Society Field Guide to North American Wildflowers. Eastern Region*. Alfred A. Knopf, New York. 1979.

Nuttall, Thomas. *A Journal of Travels into the Arkansas Territory During the Year 1819*. Edited by Savoie Lottinville. University of Oklahoma Press, Norman. 1980.

Rhodes, Richard and the Editors of Time-Life Books. *The Ozarks*. Time-Life Books, New York. 1974.

Rickett, Harold William. *Wild Flowers of the United States*. Vols. 1, 2, 6. New York Botanical Garden and McGraw-Hill, New York. 1965, 1967, 1973.

Stokes, Donald and Lillian. *A Guide to Enjoying Wildflowers*. Little, Brown, Boston. 1985.

Tanner, Ogden and the Editors of Time-Life Books. *New England Wilds*. Time-Life Books, New York. 1974.

Teale, Edwin Way. *North With the Spring*. Dodd, Mead, New York. 1951.

Thoreau, Henry David. *Thoreau in the Mountains*. Commentary by William Howarth. Farrar, Straus, Giroux, New York. 1982.

Young, Andrew. *A Prospect of Flowers*. Penguin Books, New York. 1945.

Quality Printing and Binding by:
Palace Press
3 Mount Sophia #03-00
Chang Mansion
Singapore 0922